max galli

midnight to six

illustrations and thoughts about the mod scene

Max Galli - Midnight To Six
Third edition - february 2013

Cover and back: original illustrations and graphics by Max Galli

© Max Galli, 2002-2013. All rights reserved worldwide.

ISBN 978-1-291-29732-4

No part of this book shall be reproduced, stored in a retrieval system, or transmitted by any means - electronic, mechanical, photocopying, recording or otherwise - without written permission from the author or the publisher.

If you think that "Mod" is only something about parkas, targets and seaside riots, well, you'd probably better close this book and give it to a friend as a Birthday present.

Midnight To Six is a book about style, photography and coolness. But it's also a book about friendship, clublife, clothes and attitude.

The idea behind *Midnight To Six* - the very concept of this book - came to my attention more than ten years ago, along with a bagful of memories about my early life. My father was a professional photographer in the 60s and 70s and I was lucky enough to grow up with his beautiful black and white photographs: actresses, models, landscapes and night life. All this material was always at hand, as I used to look at those pictures with growing curiosity, often lingering on the contrast between lights and shades.

I've never been a good photographer and never will be. The talent I inherited from my dad chose a different way to express itself - *the way of illustration*. Yet, needless to say, all the images I grew up with stayed archived in my brain, ready to spread their influence on my very own art.

Midnight To Six is a collection of 'illustrated photogaphs', begun in 1999 while I was living in London. It started almost as a game, something like 'see if I can take pictures with a pen, rather than with a camera' - honestly - and it went on and on through the years, until today, with these thirty-plus ultra-detailed line illustrations, whereas I tried to reproduce the same light-shade contrast I learned from my dad's pictures. Some illustrations were ready to be included in the book, others needed a bit of 'style updating' or restoring, as the paper where they've been drawn went yellowish. Many others have been realized for this book and have never been published before. For all of them I wrote brief sentences, a sort of 'stop motion' comments to highlight each and every single illustration.

The result is a sort of 'illustrated journey' through the many faces of Mod: from the early jazz-oriented *modernists* to the late 60s *freaksters* and several other types of scenesters in between.

The title 'Midnight To Six' is a tribute to the Mod Scene and to one of the 60s bands I

always enjoyed very much listening: The Pretty Things. In the song's text is included the very substance of this book:

*I never see
the people I know
in the bright light of day
so how can I say
that you're any friend of mine*

*See you anytime
I'm feelin' fine
Midnight til six
that's my time
that's your time*

So, there we go. I put so much effort in the making of *Midnight To Six*, during the years. There's been a 'first edition', back in 2002, published in London, but it was sort of 'a rough sketch' of what this book is now. A second edition - square sized - was published last year, very different from the first one, with more illustrations. And now we have this third edition, bigger in size and slightly different from last year's one, with a few reviews (both critics and readers) and an interview.

What I wanted to do since the first set of illustrations was an 'in deep' vision about the way we perceive the essence of being Mod.

I hope you'll enjoy this book as much as I did drawing the illustrations and writing the sentences.

'*It's all in the details*', as we all know.

Max Galli, Rome, january 2012 - january 2013

*To my dad,
Franco Galli, photographer.
In loving memory*

snapshots

"…he's a cool cat and he's got his own sensitivity. He captures frames of clublife with incredible ease, as he lives in the same landscape he's used to portray…"

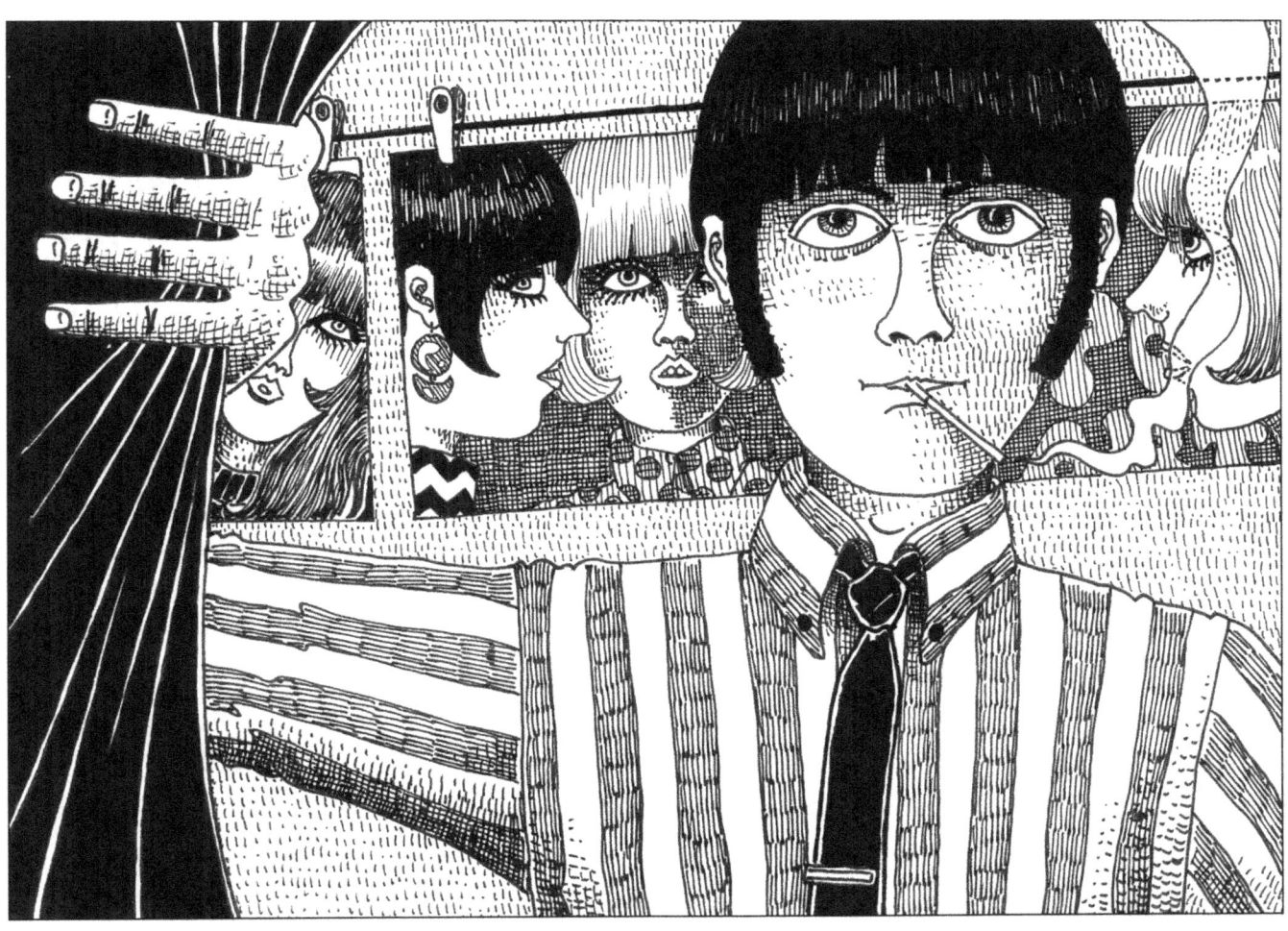

"…and there were three of us just outside the 'hideout', standing before the front door, as we were the lords of the castle waiting for the rest of the knights to start the gathering…"

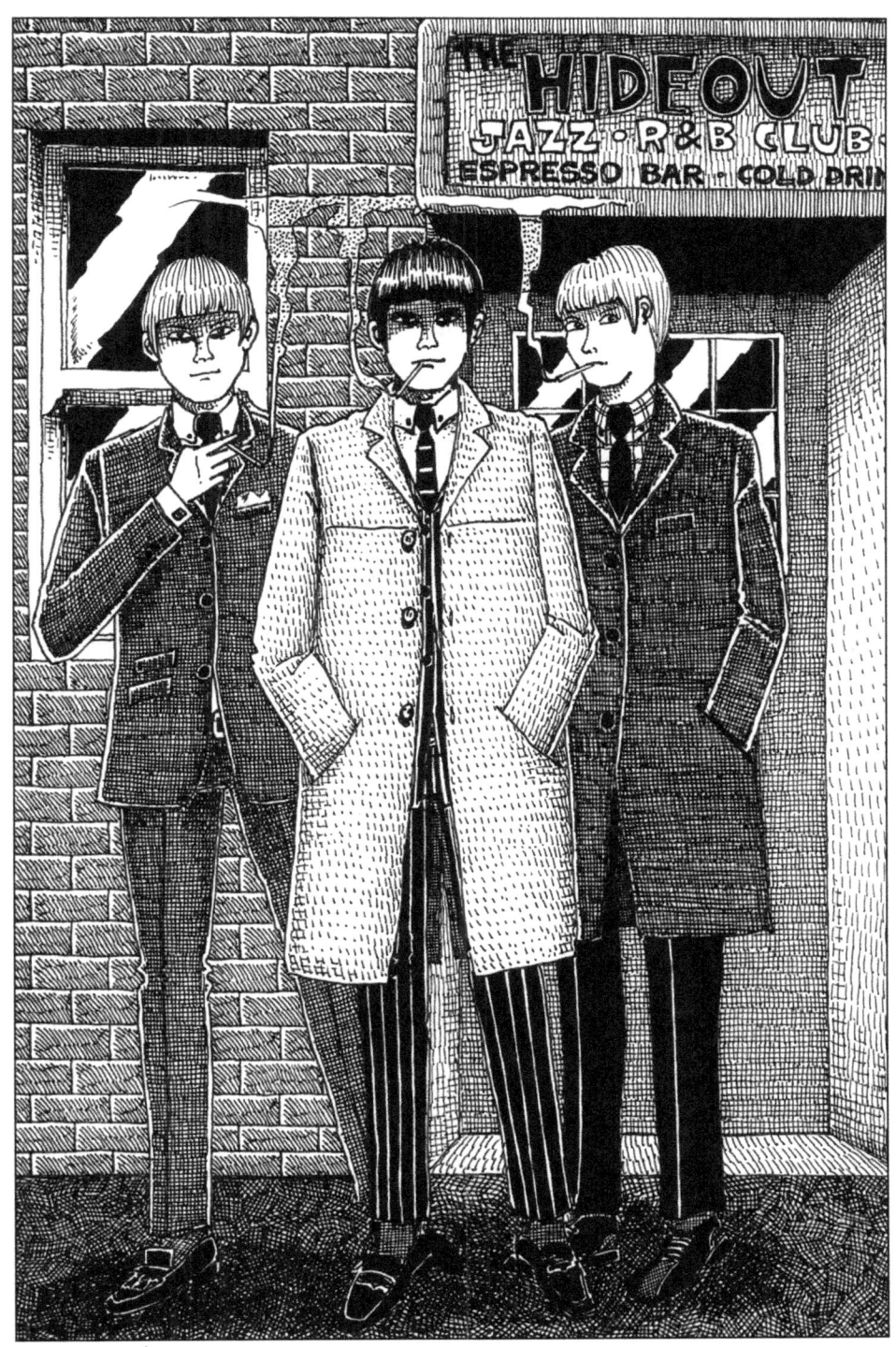

"…where beautiful short-haired girls would talk all night about everything, quite aware of attracting the attention of the male audience. They knew what they wanted and - just the opposite of their mothers - they only chose the best…"

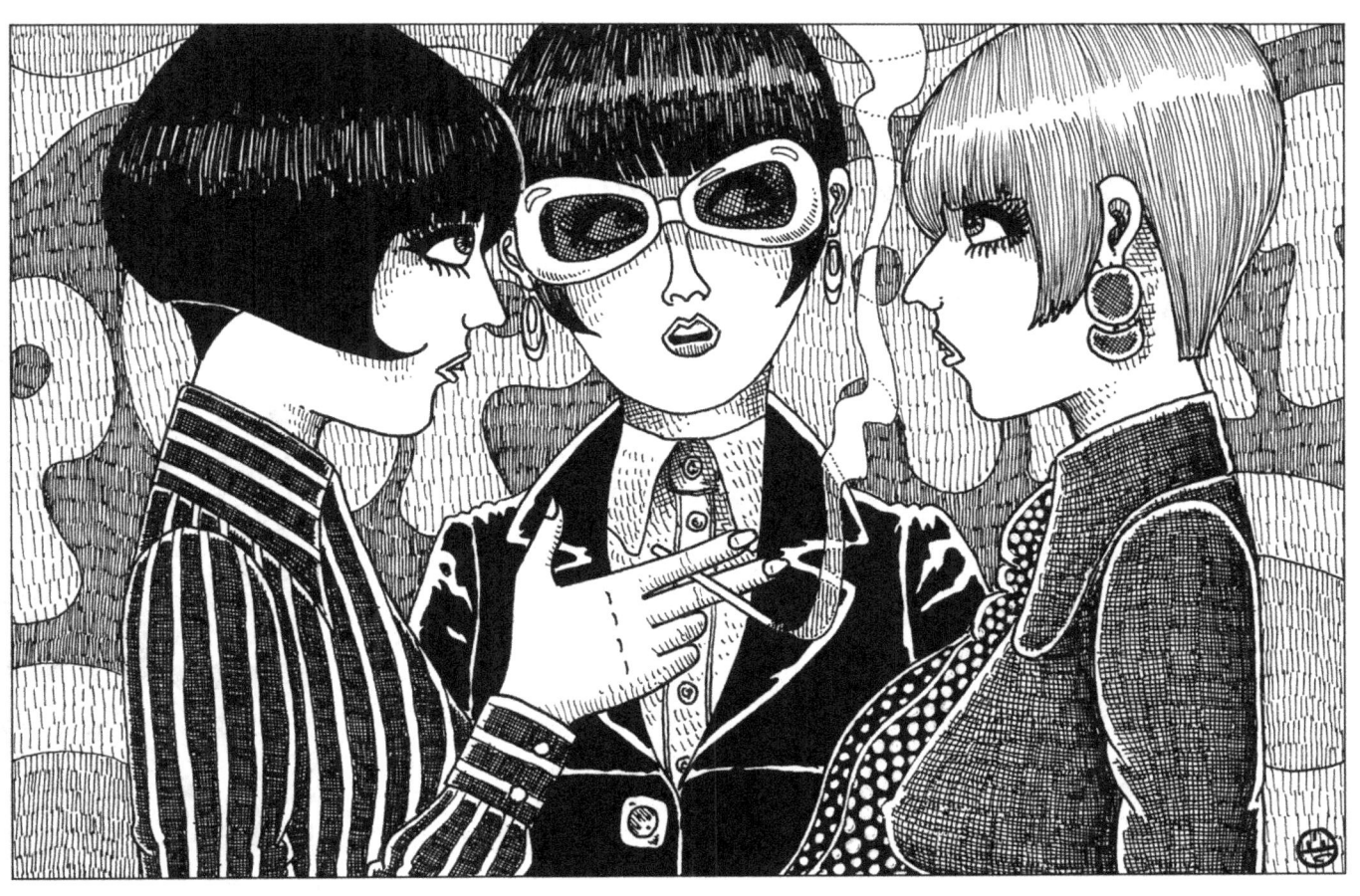

"...strolling along what we usually called 'boutique street', to taste new gear coming out every week, in a carousel of styles and colours..."

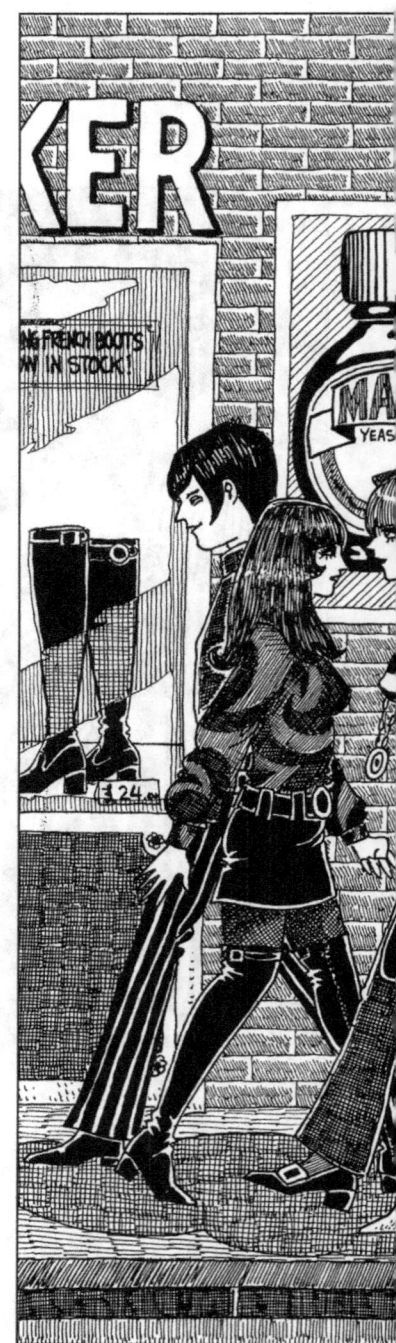

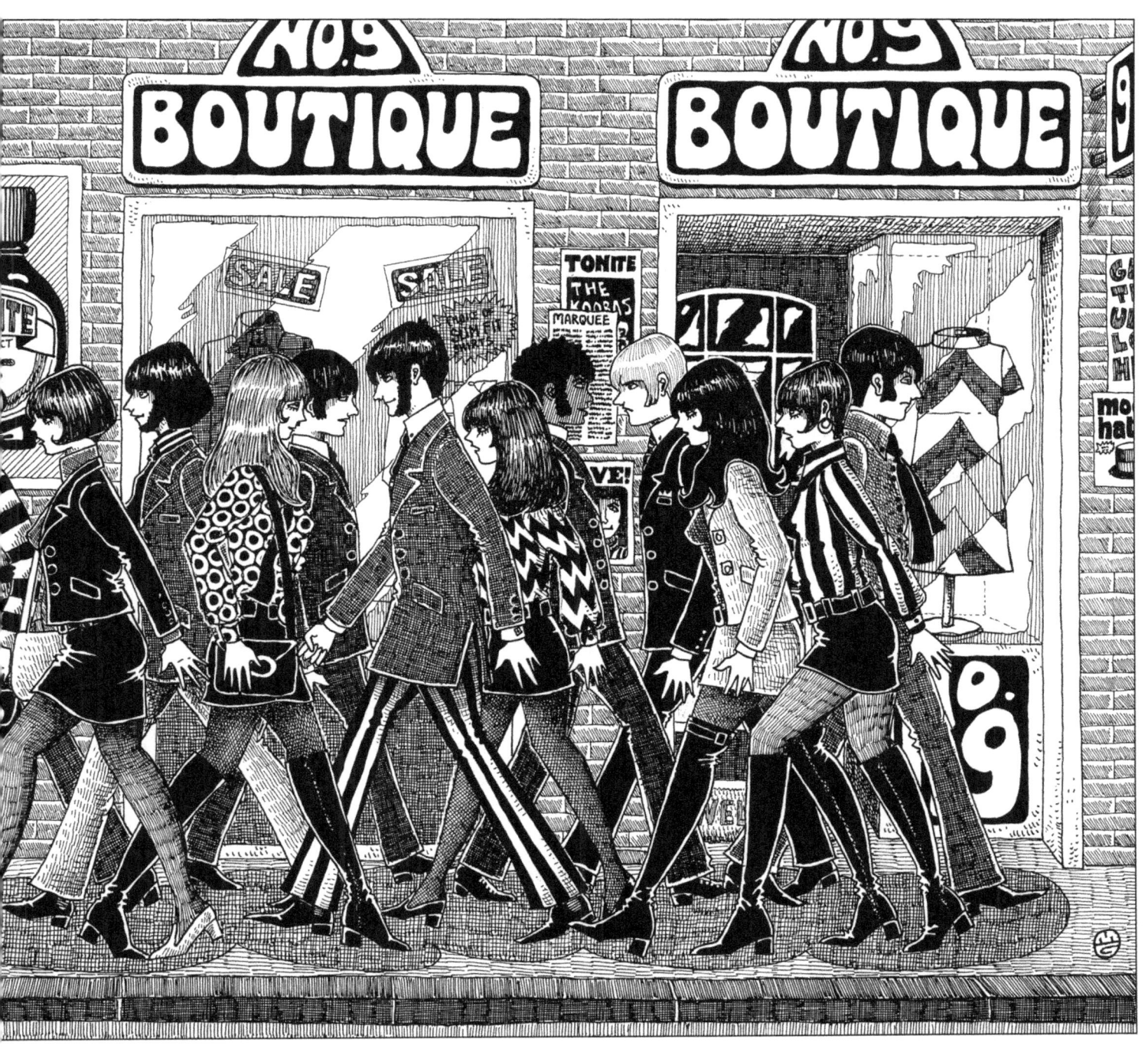

"...the band was playing a mix of jazz and r&b. We were all packed in that small basement club, breathing the smoke of thousand cigarettes, but we didn't care. All we care about that night was the music..."

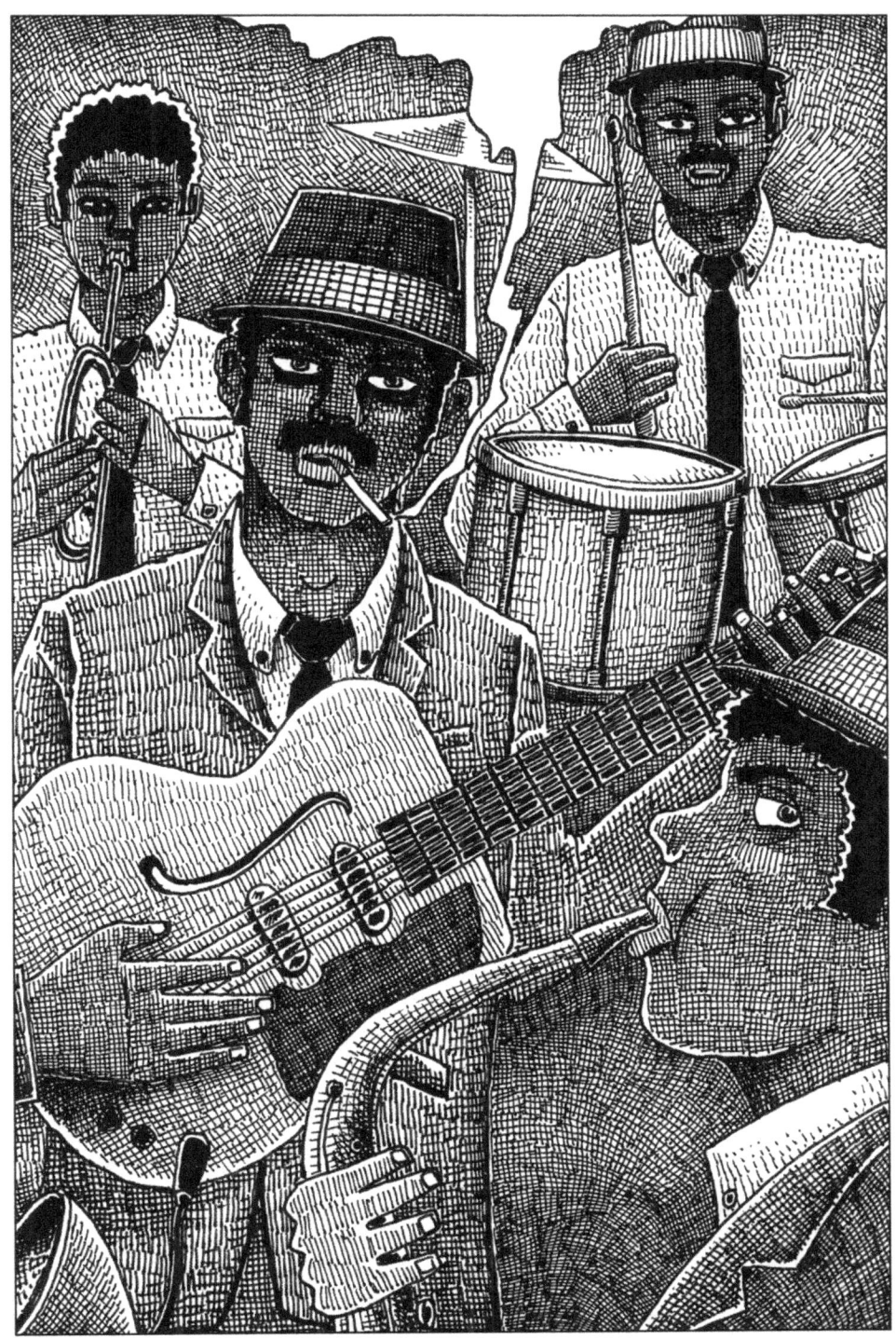

"…that chick gained respect from all the guys, as she was sharp and attractive, and she could dance for hours with her very own style, leaving most of them aside to look at her perfect moves: she was the queen of the in-crowd…"

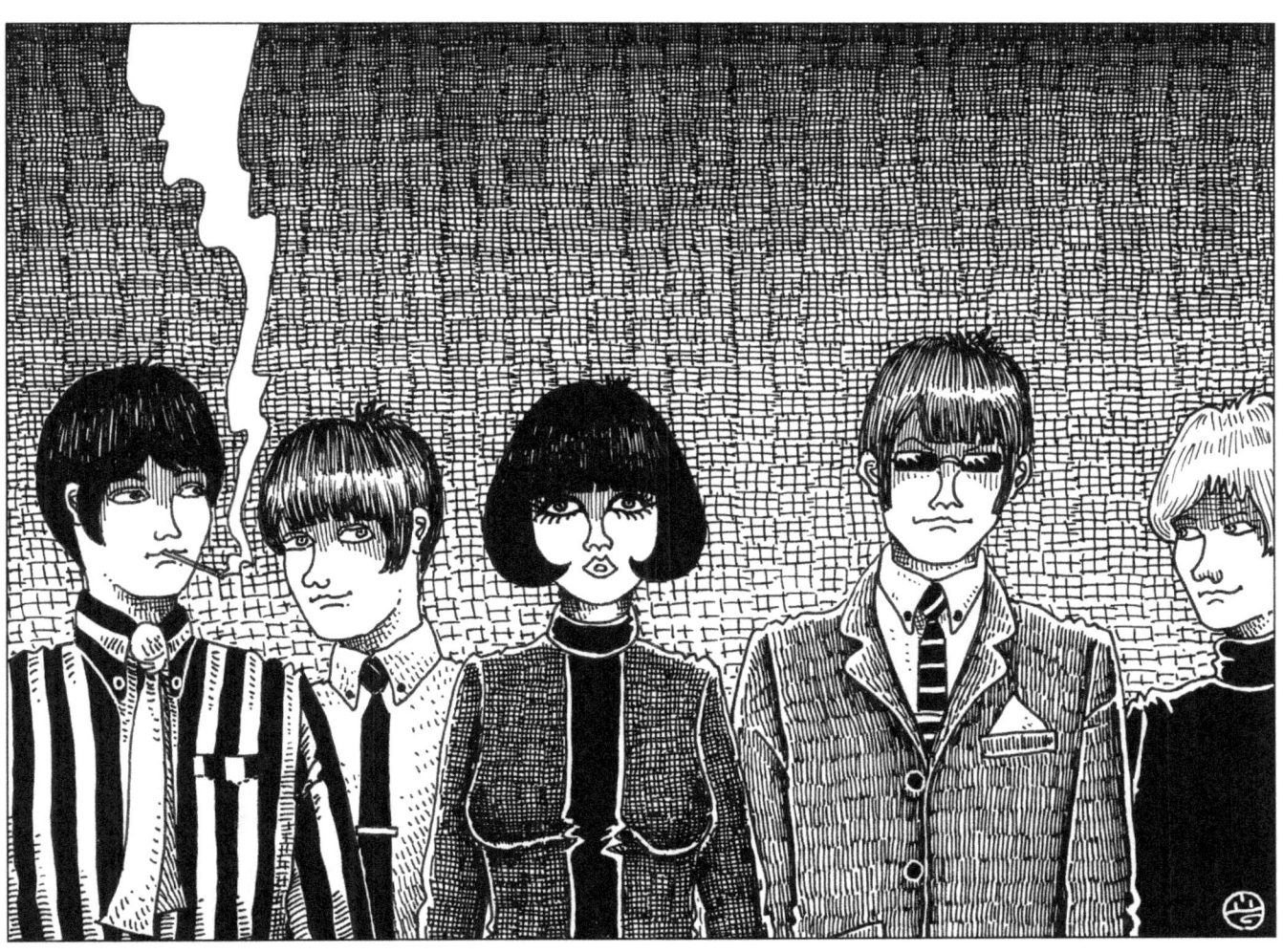

"...the guys were back in town. They were smart, arrogant and sharply dressed. They knew exactly what to wear and how to act, and we loved their style..."

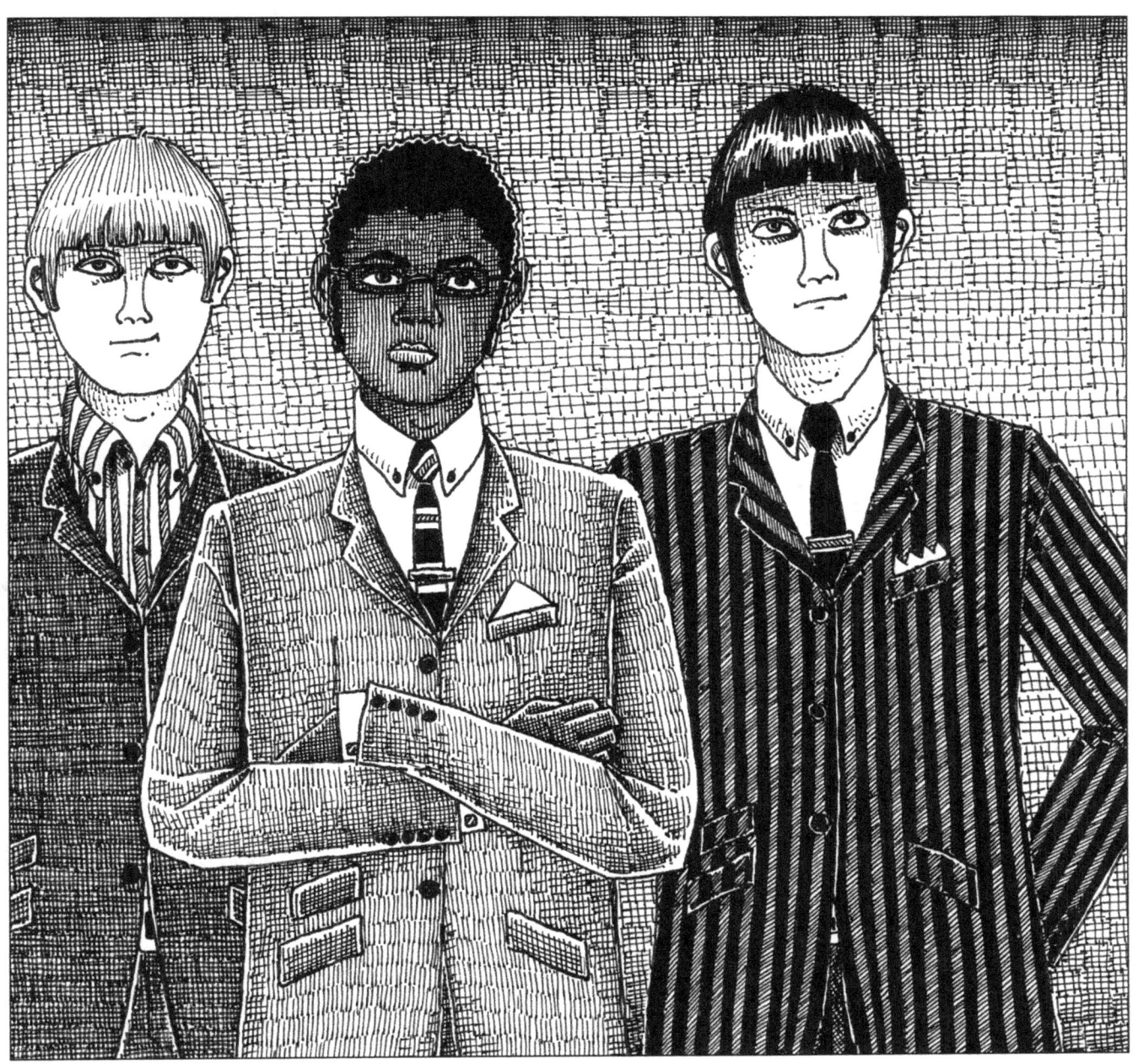

"...the meeting was at 'the cave', in the late afternoon, just three hours before the doors of the club opened, so that some of us had enough time to check the latest gear at the shops nearby..."

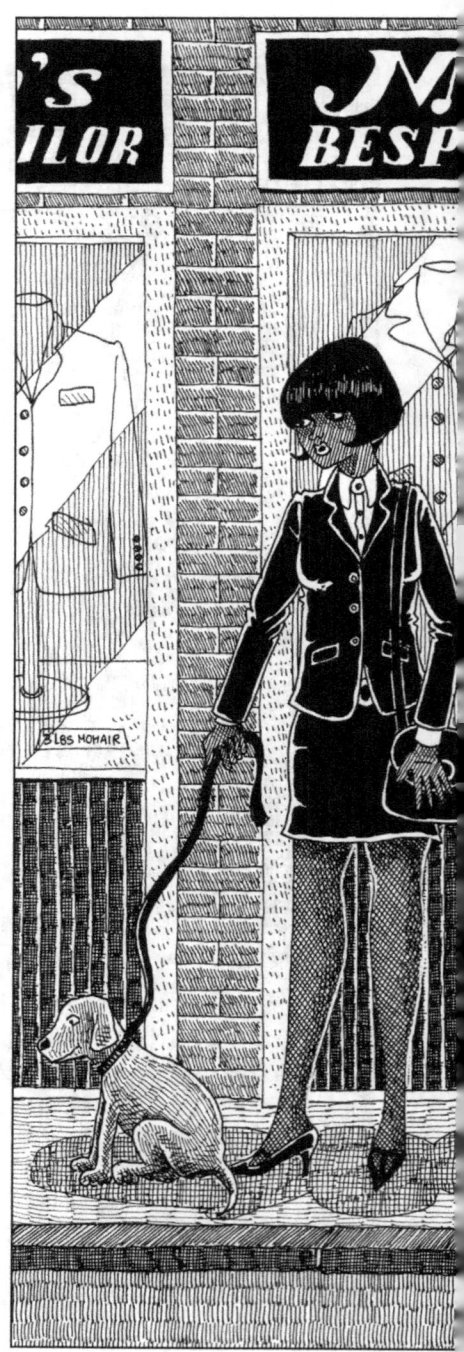

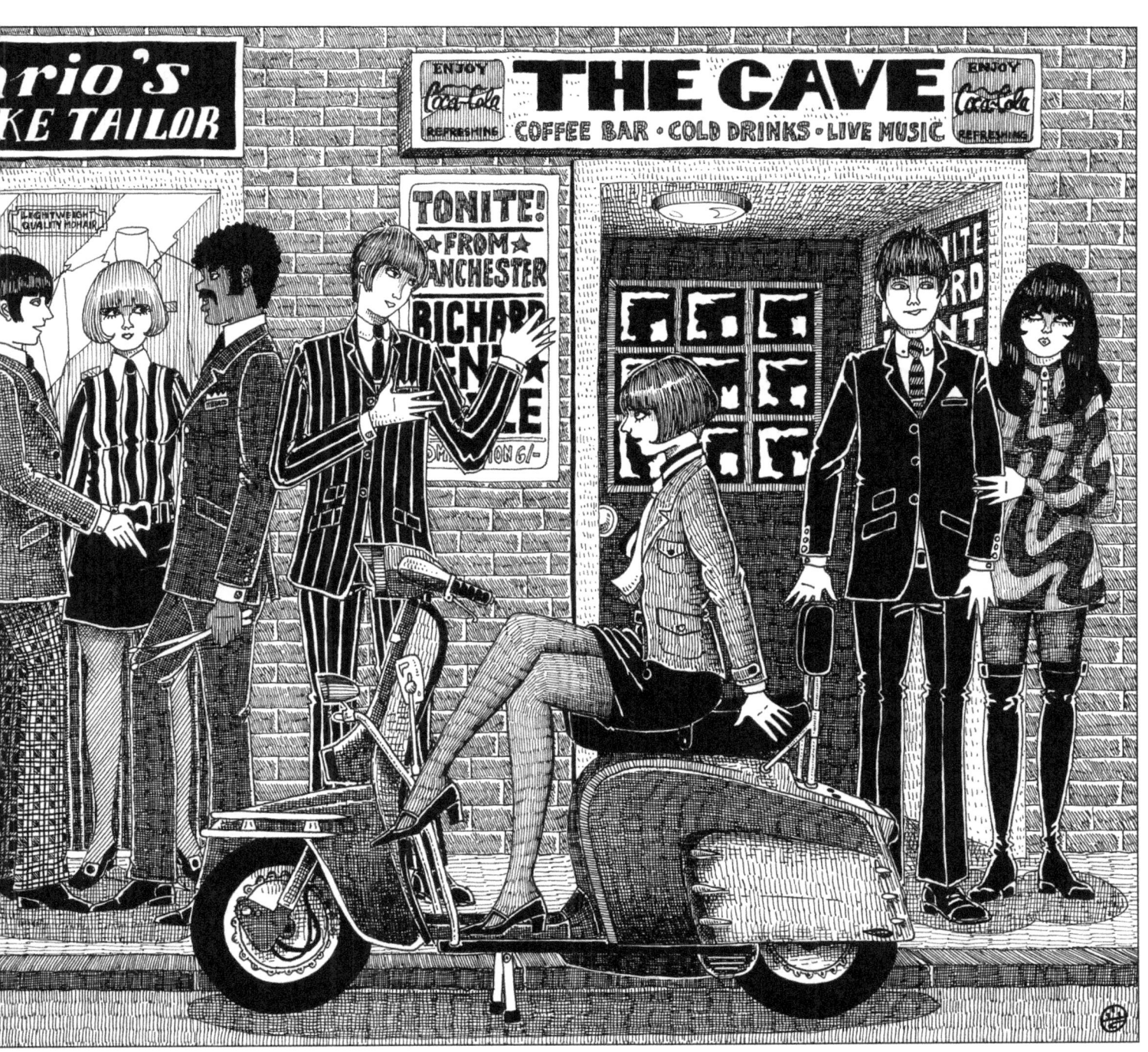

"...and we all were back in the club at night, where coolness was our philosophy and dancing our religion. Midnight to six: that was our time..."

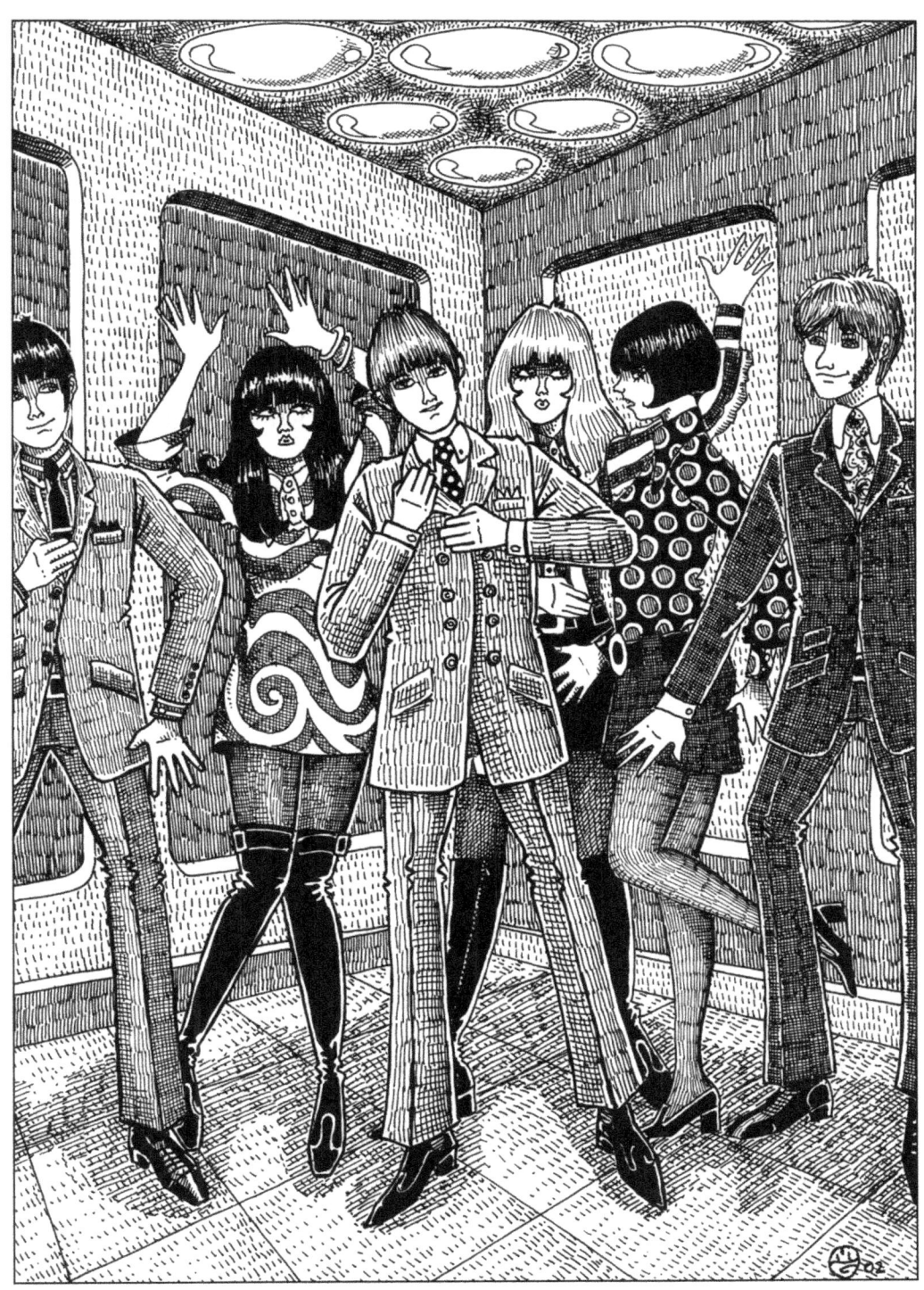

"…'The Basement' was only one of the many clubs we went to. You had to go down two dozens of steps and then you'd find a small, squeaking wooden door - heaven, rather than hell, was just behind that door …"

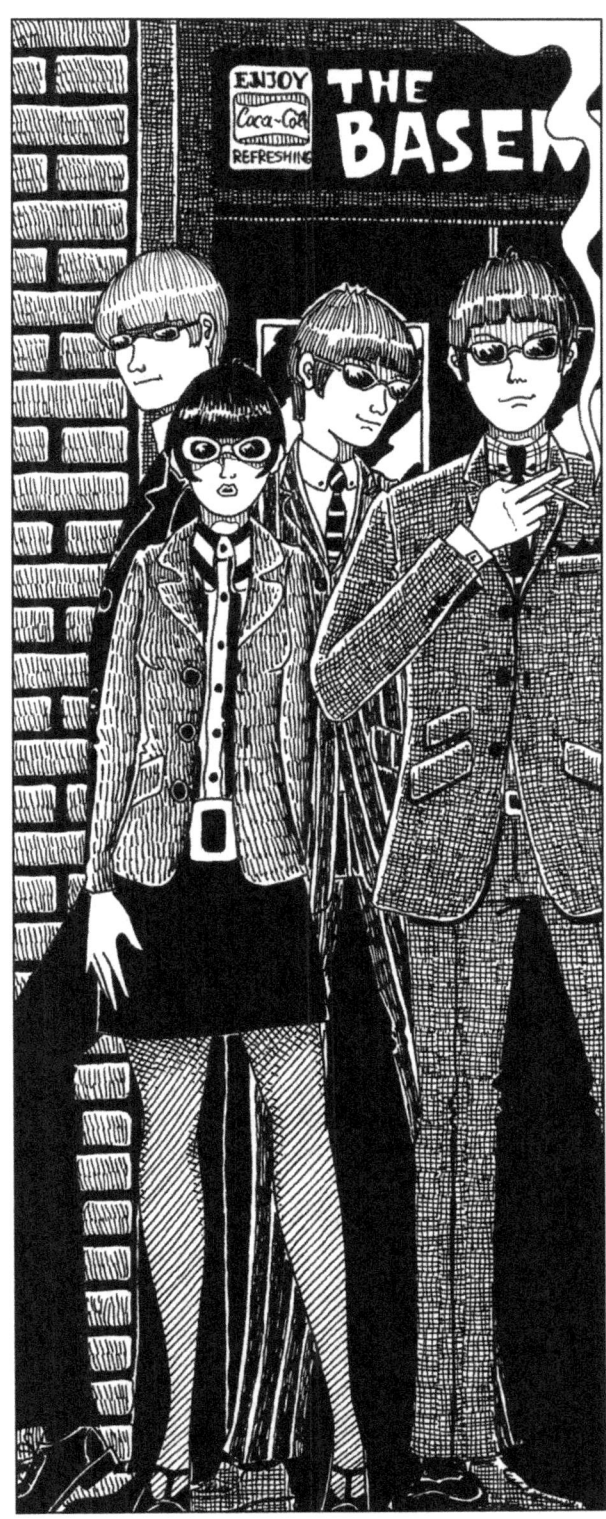

"...Italian black coffee and cigarettes, that was what we needed to start the night in the right way..."

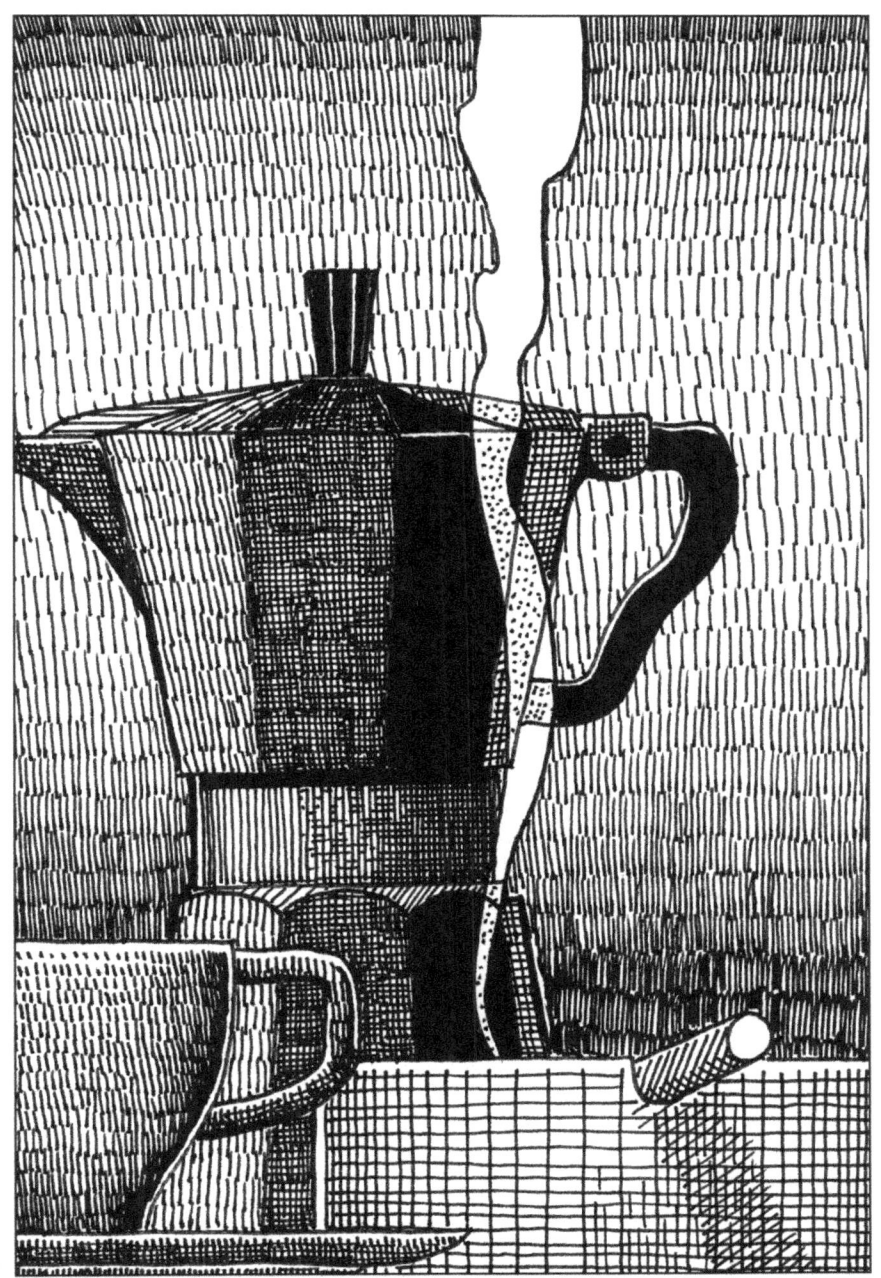

mod-els

"…Shirley always looks fine, especially when she wears one of her two-tone shirts…"

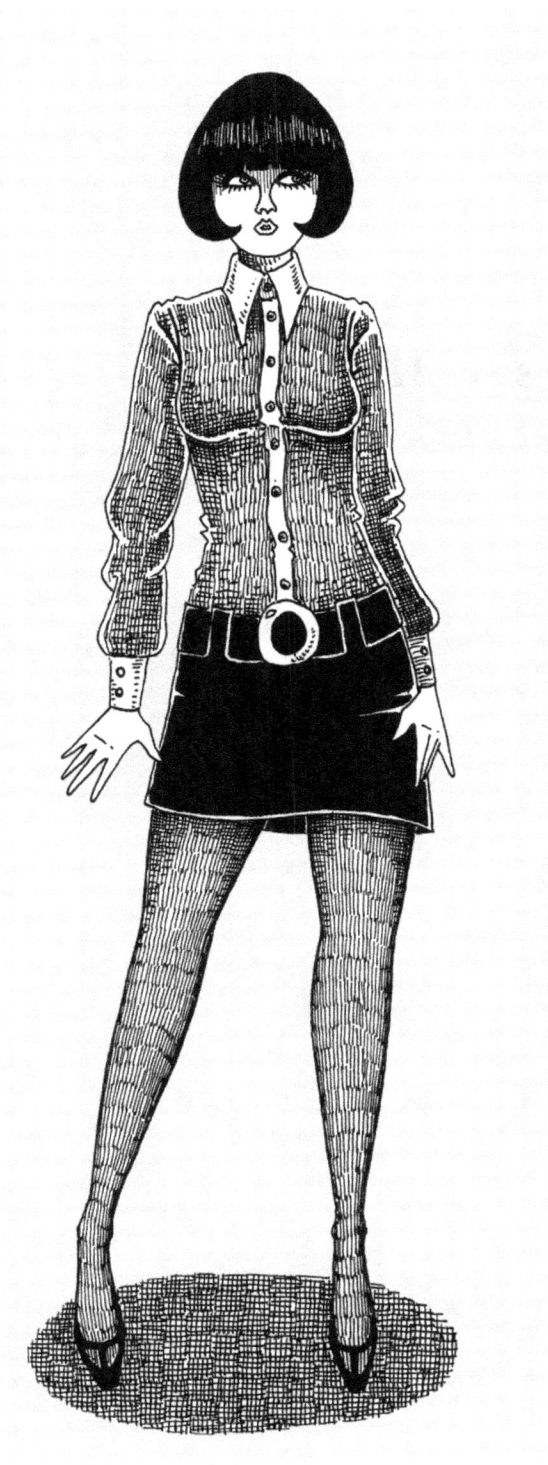

"...needless to say, Mike and Shirley have that natural feeling with clothes: whatever they wear suit them perfectly..."

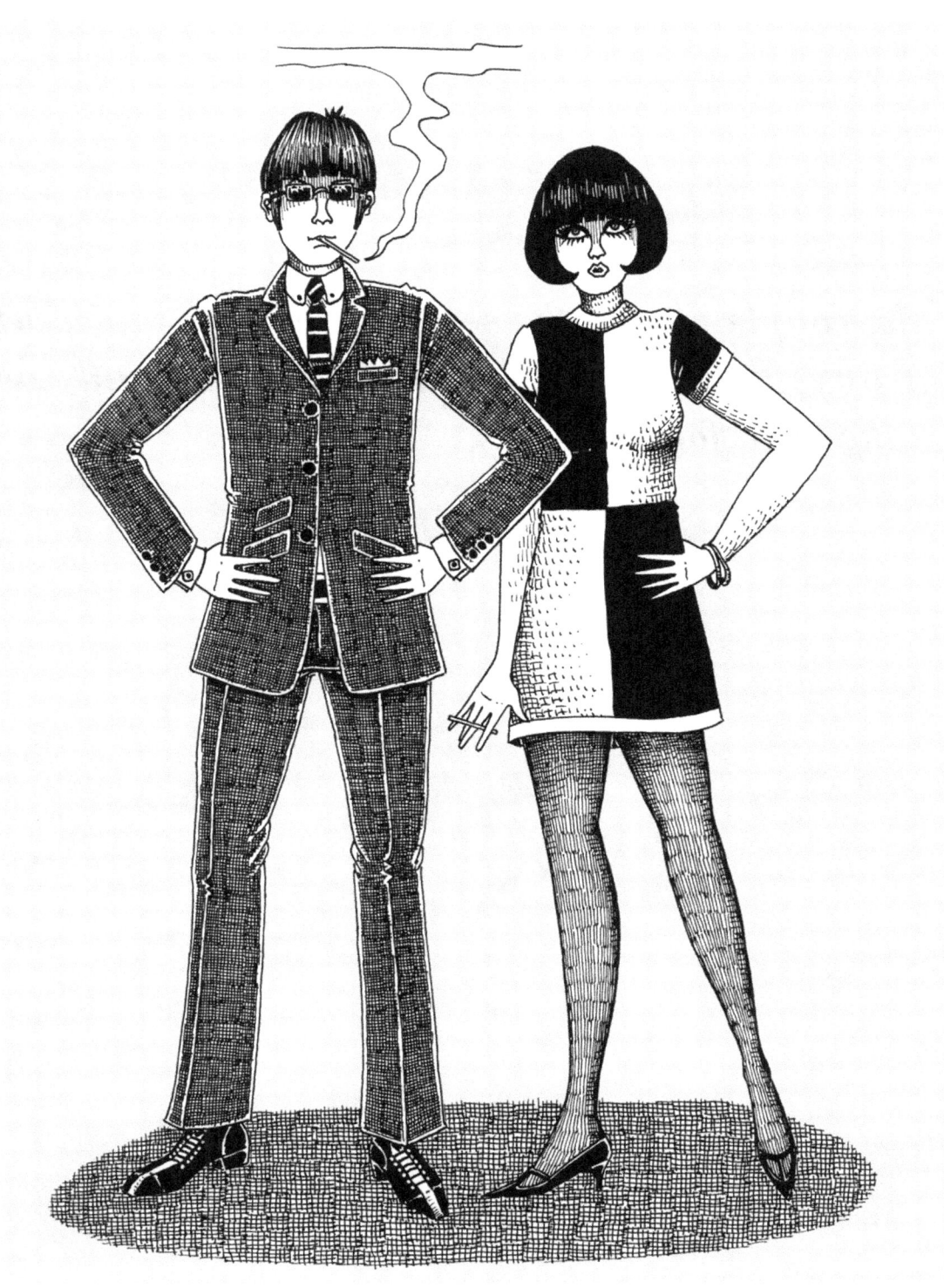

"...the couple played the secret agent part much better than any James Bond lookalike... you could easily mistake them for real spies..."

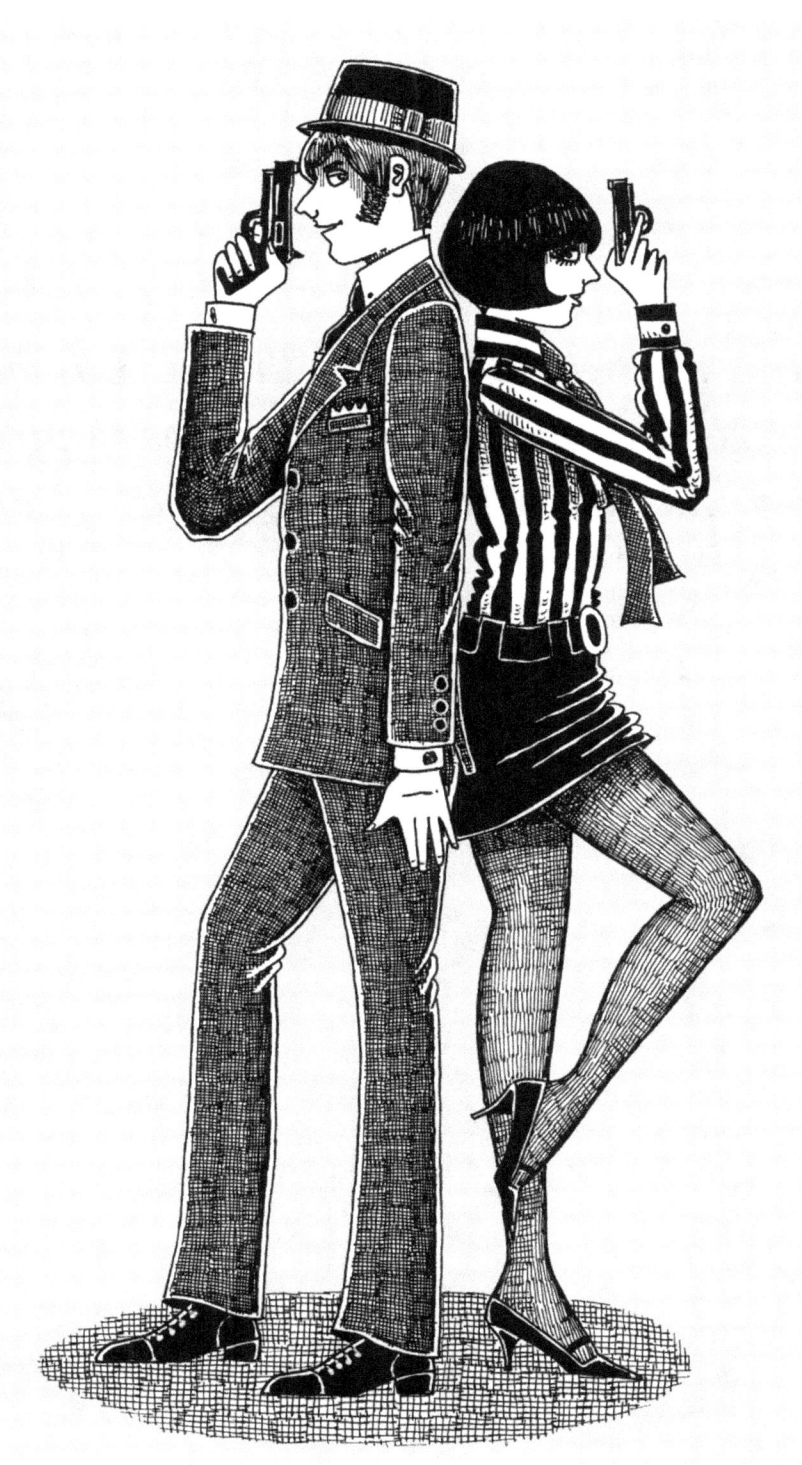

"...Christine wanted to pose with her Lambretta, as she's a very good rider. She usually goes to pick up her friend Irma and then drives straight to the club..."

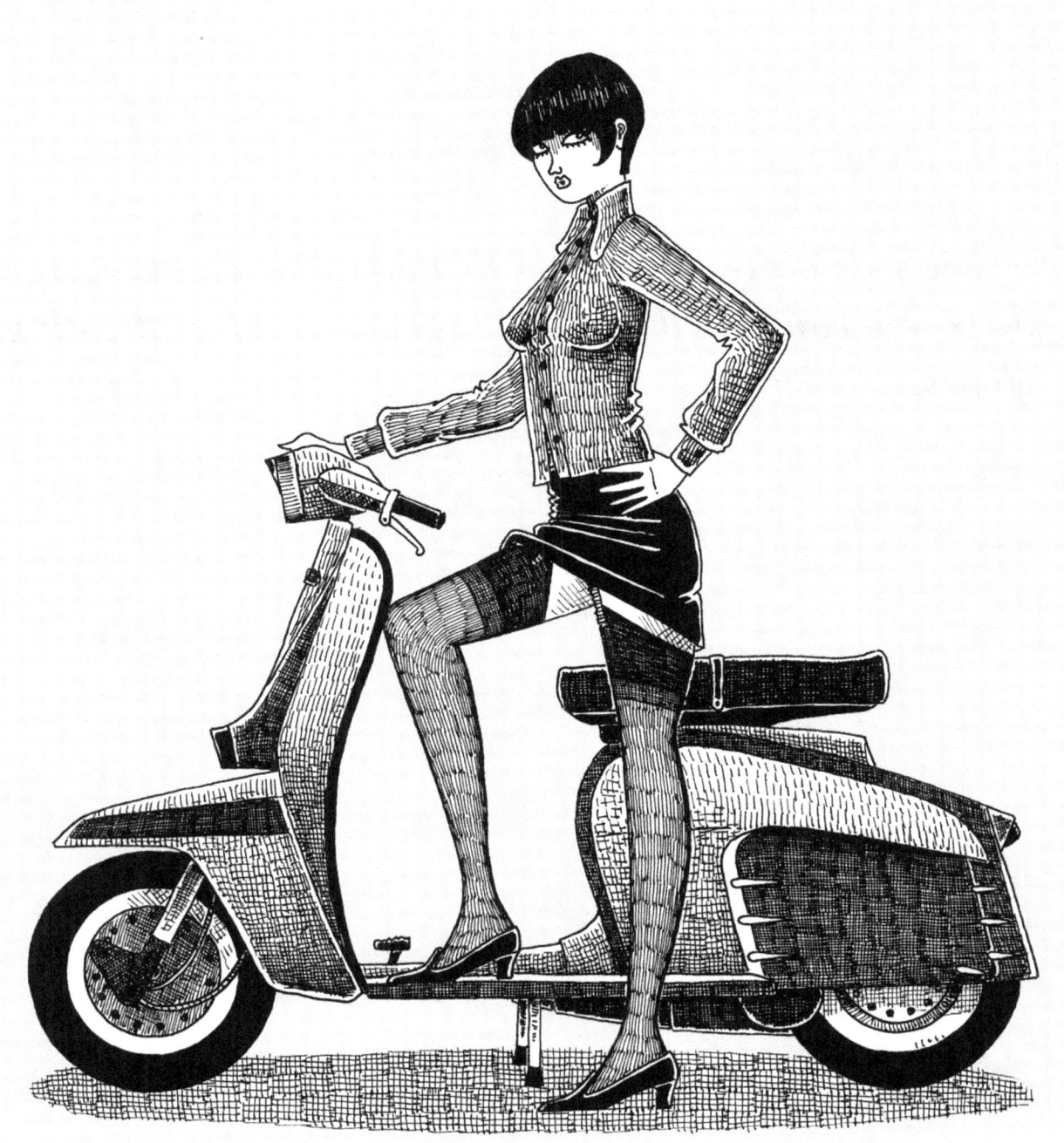

"…she was quite fascinated by those new candy-stripe shirts, you can find them in a huge variety of contrasting colours…"

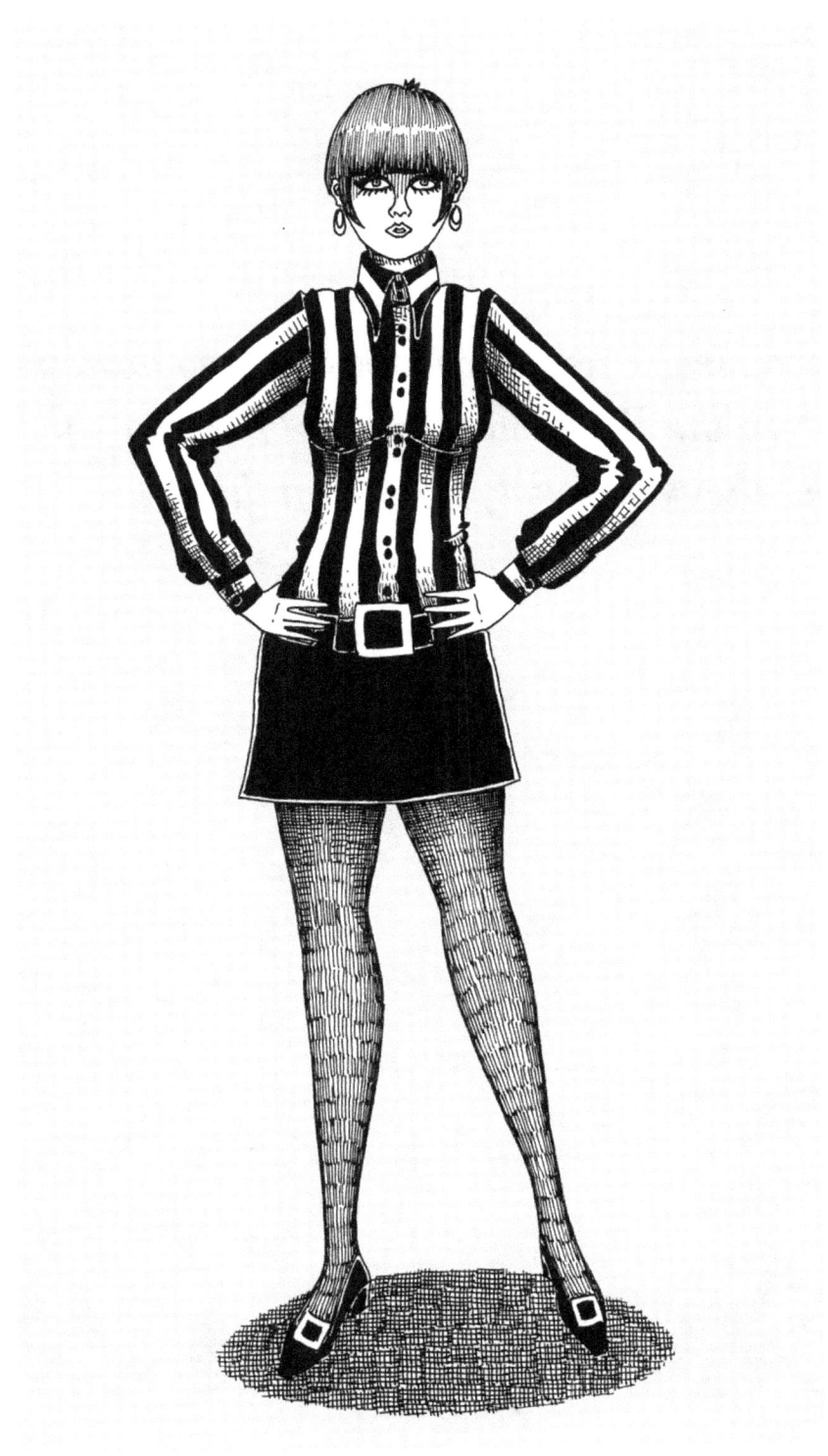

"...these two sisters usually work as go-go dancers in more than a club in the West End. Not only are they professional dancers, but they absolutely love what they do..."

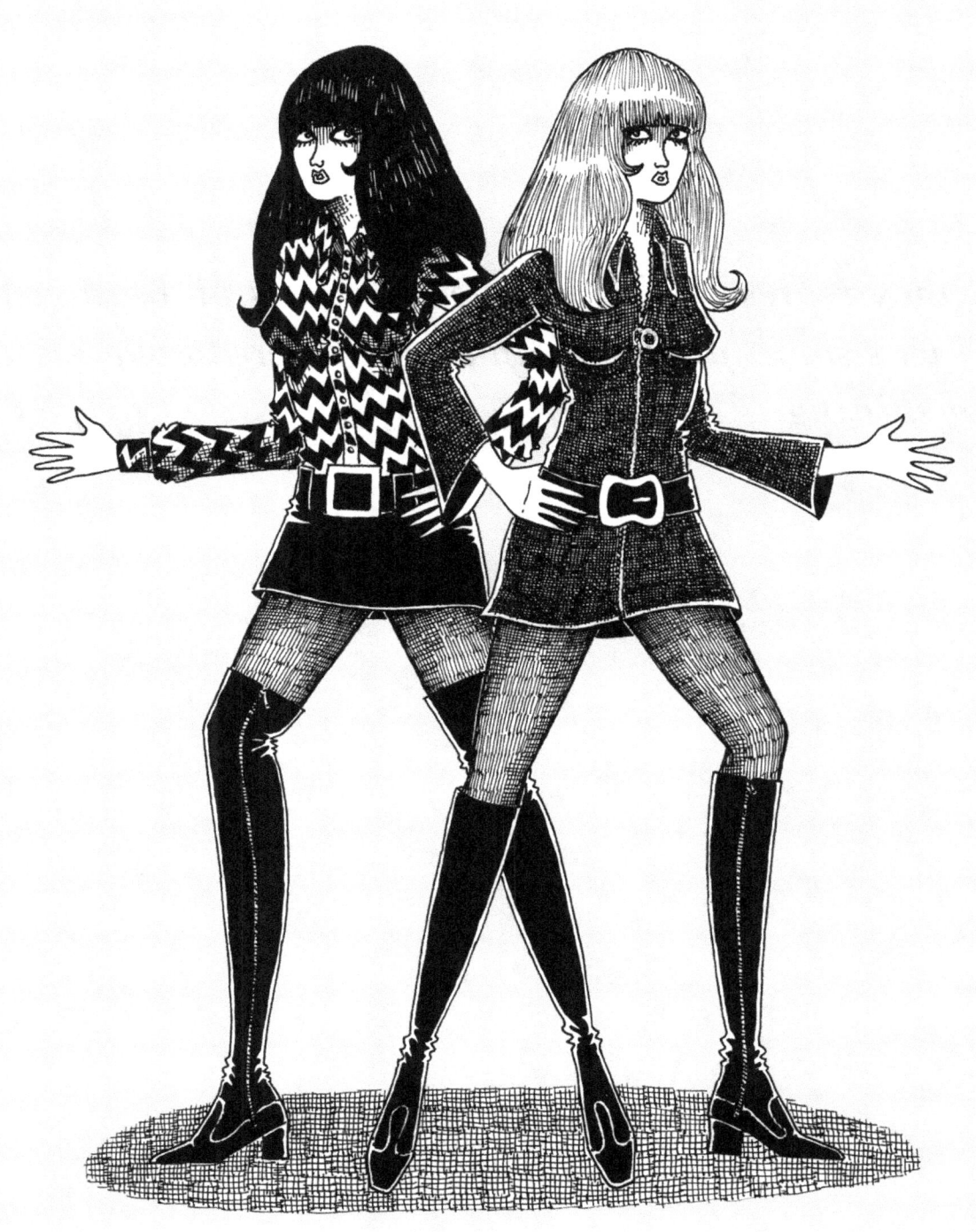

"...they represented two different forms of beauty: the girl was smart and sexy, and the Lambretta was stylish and shining..."

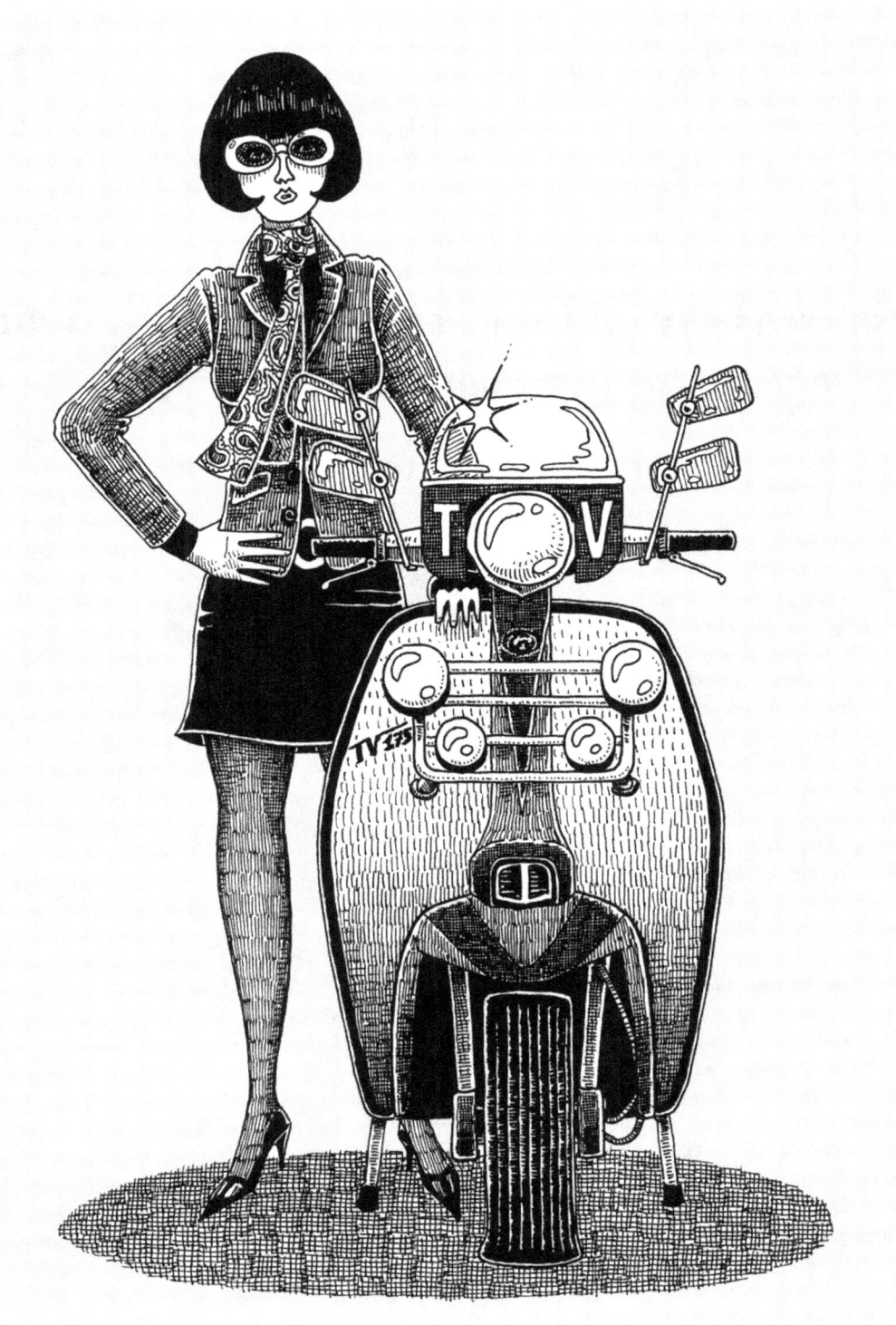

"...she was shy and sexy at the same time, a ultra-hip chick with a girl-next-door attitude..."

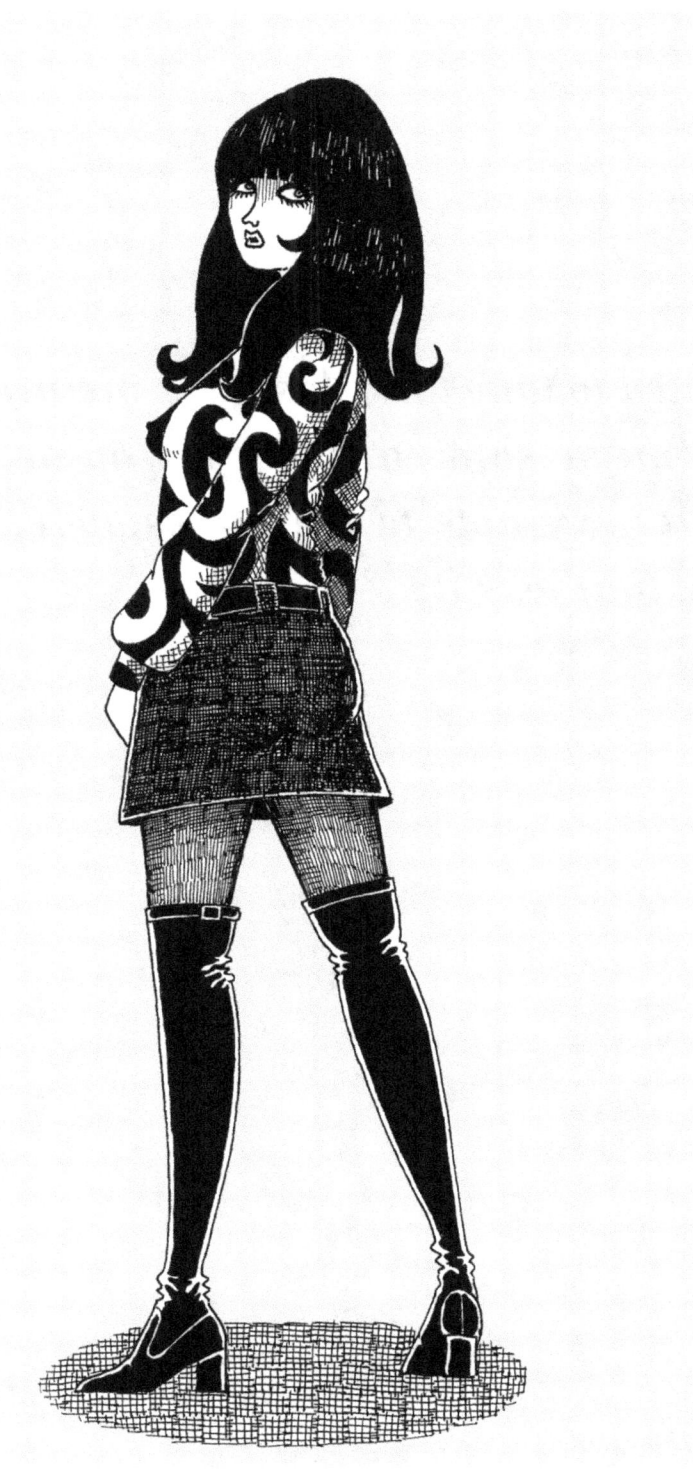

"*...I wanted to take these last four pictures in a modern living room: a sofa, a wall, an op-art poster. Sally added that sexy note to the atmosphere, sitting on the sofa. And that was it...*"

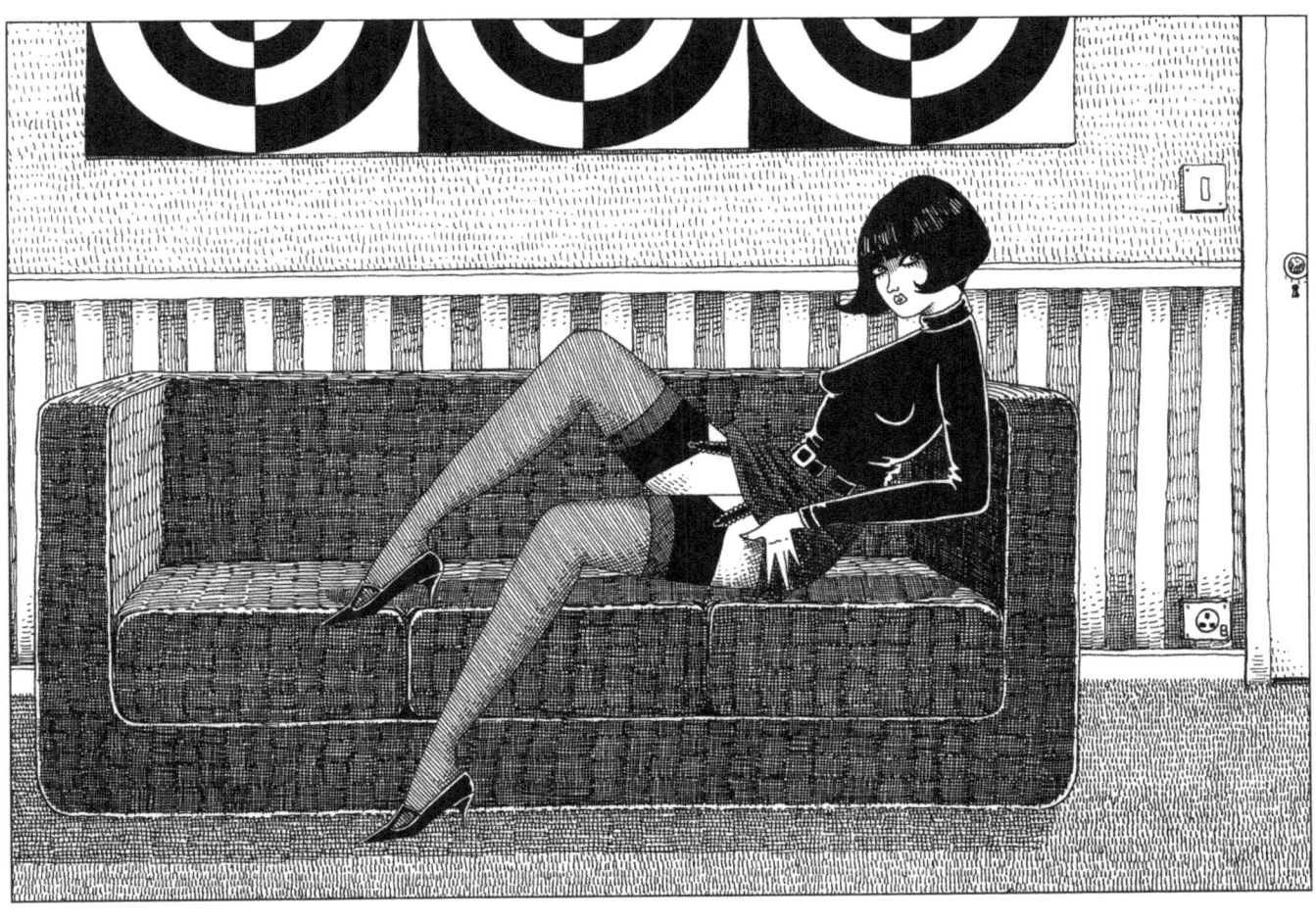

"...Steve and Kelly looked like a king and his queen, and the living room became their castle for a few minutes, a castle made of neat geometries and style..."

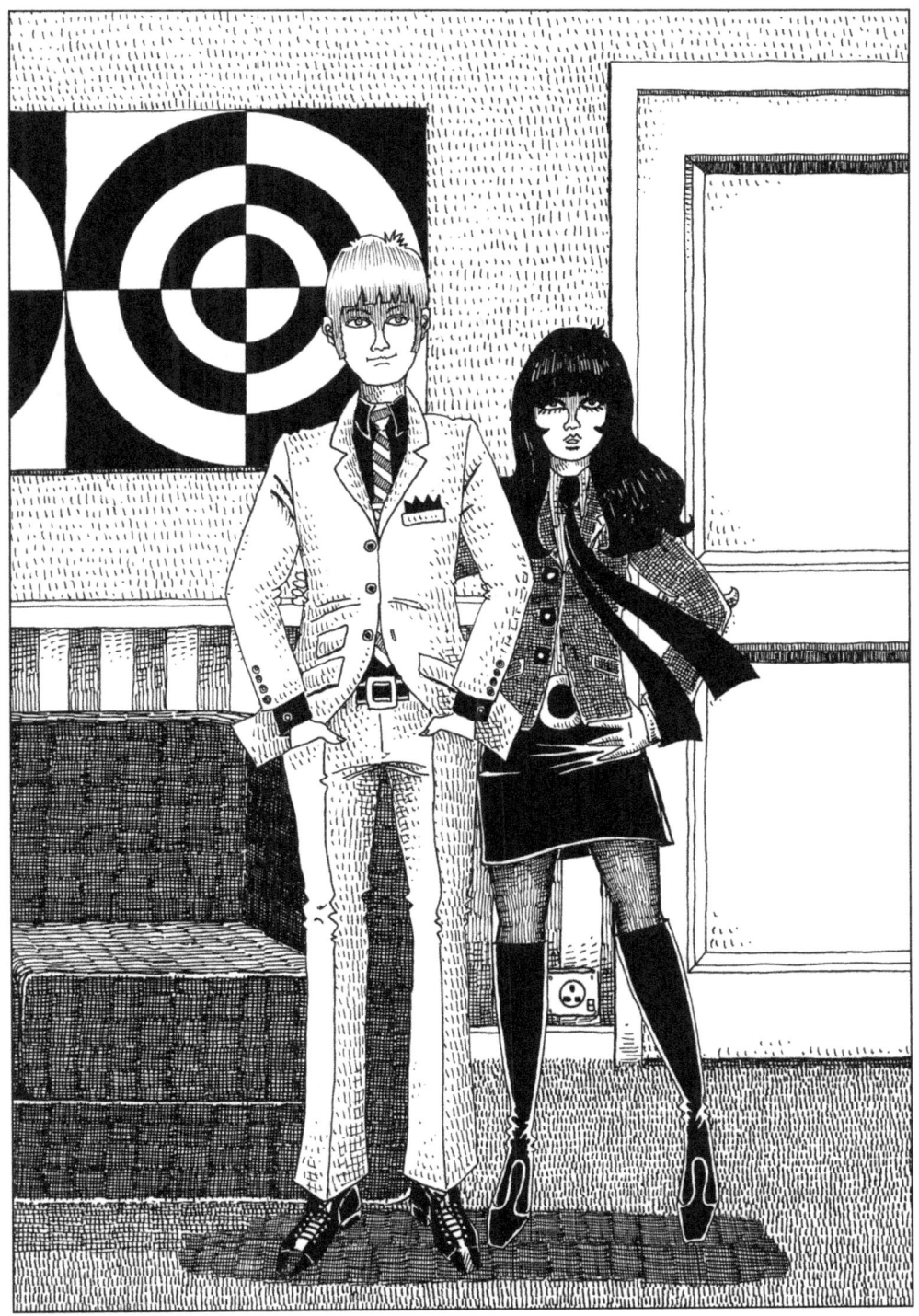

"...Do you know what the word 'sexy' means? No? Well, have a look at Jane lying on the sofa, then. She knows exactly what it means..."

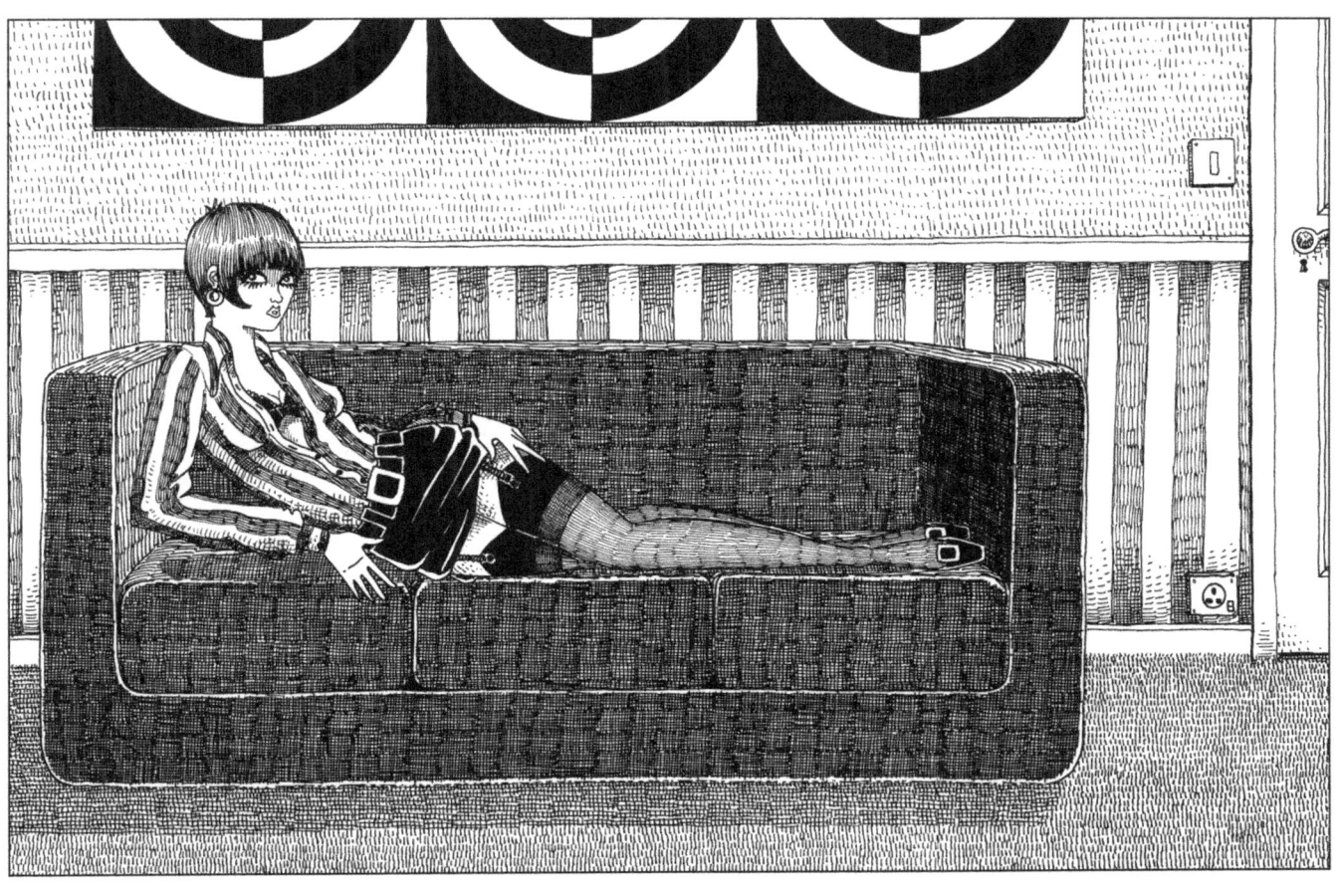

"...the living room was fine, yet it had something more to be added, and that was Lisa..."

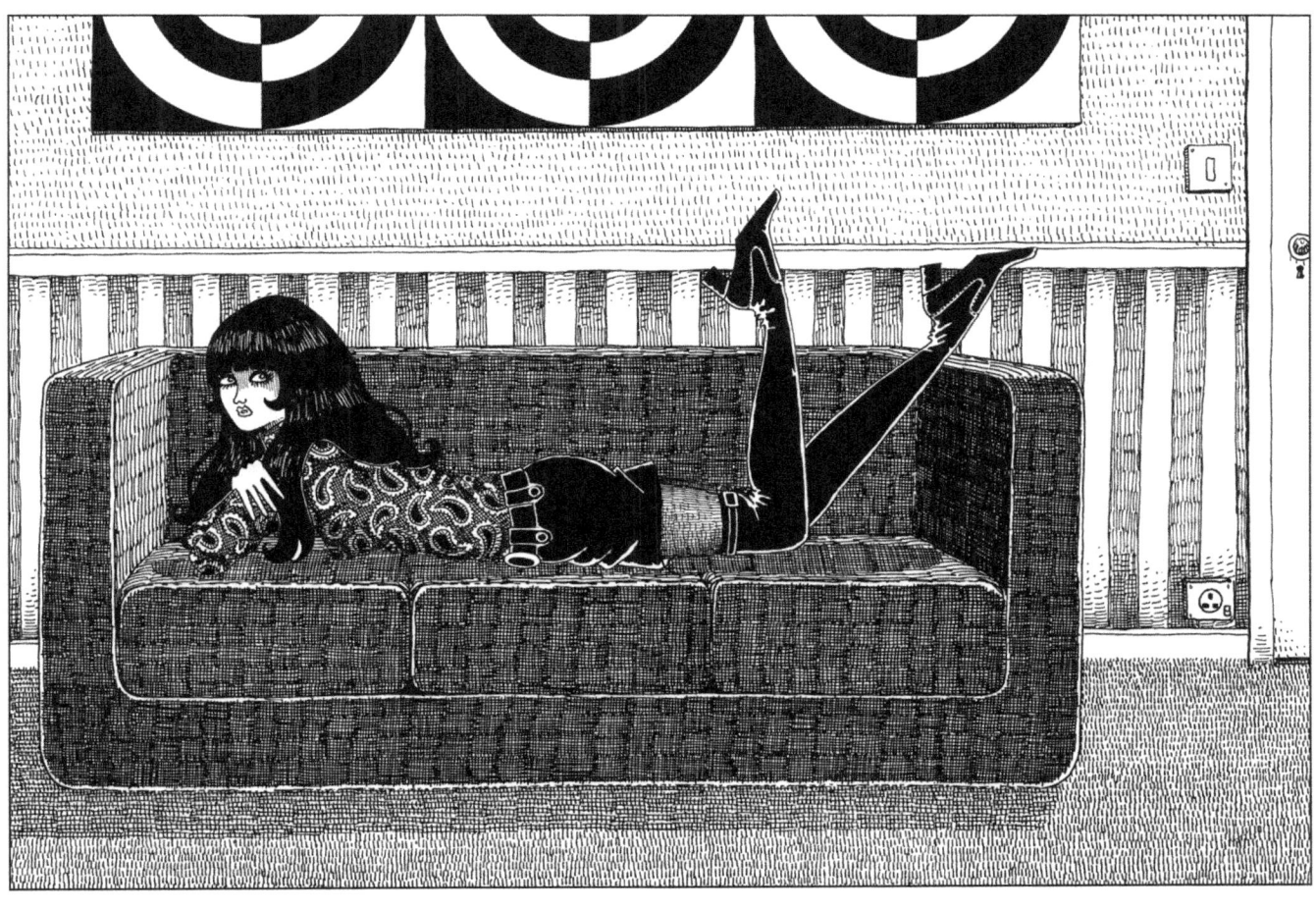

portraits

"...then I looked at her and thought: 'man, have you ever met such a sweet girl?'..."

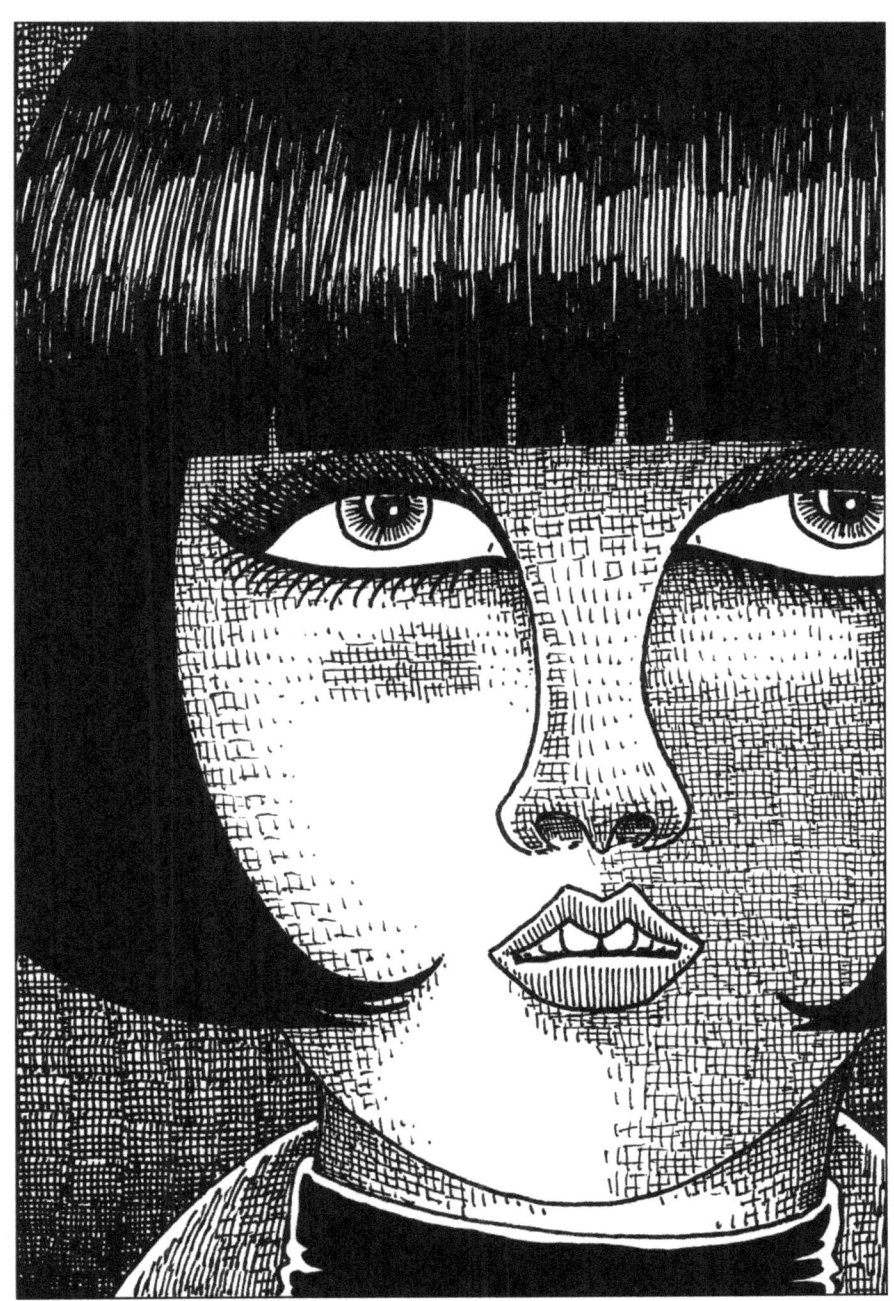

"...she had those beautiful eyes and when she looked at you, well, it was like feeling naked, harmless and mesmerized..."

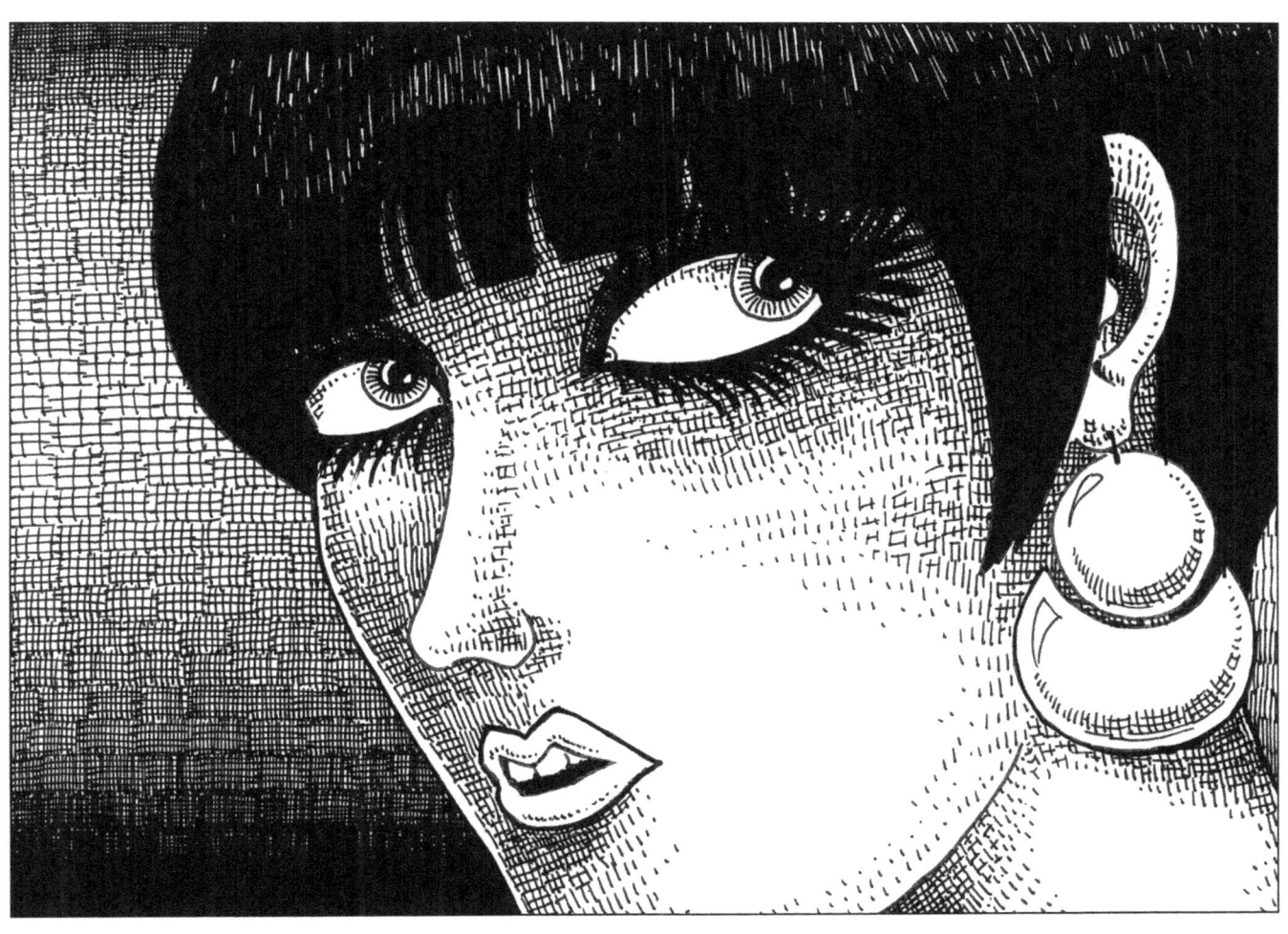

"...Irma was a very attractive girl and an excellent jazz singer. She could do everything with her voice, it had something that could dig into your heart, uncover your soul..."

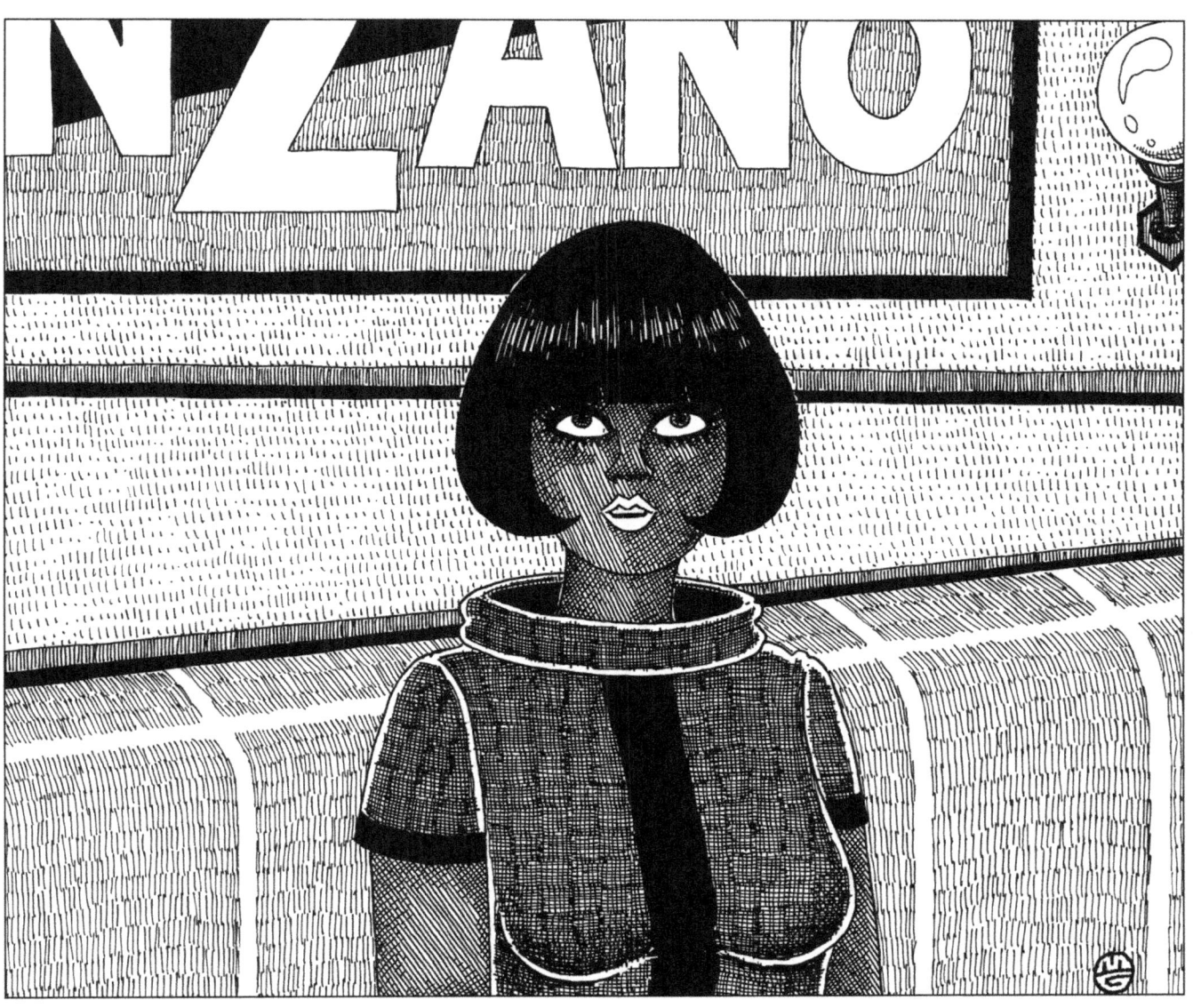

"…Dee was Irma's younger sister. She was nineteen, but she looked three or four years younger. Her voice was very sweet, but she didn't sing at all…"

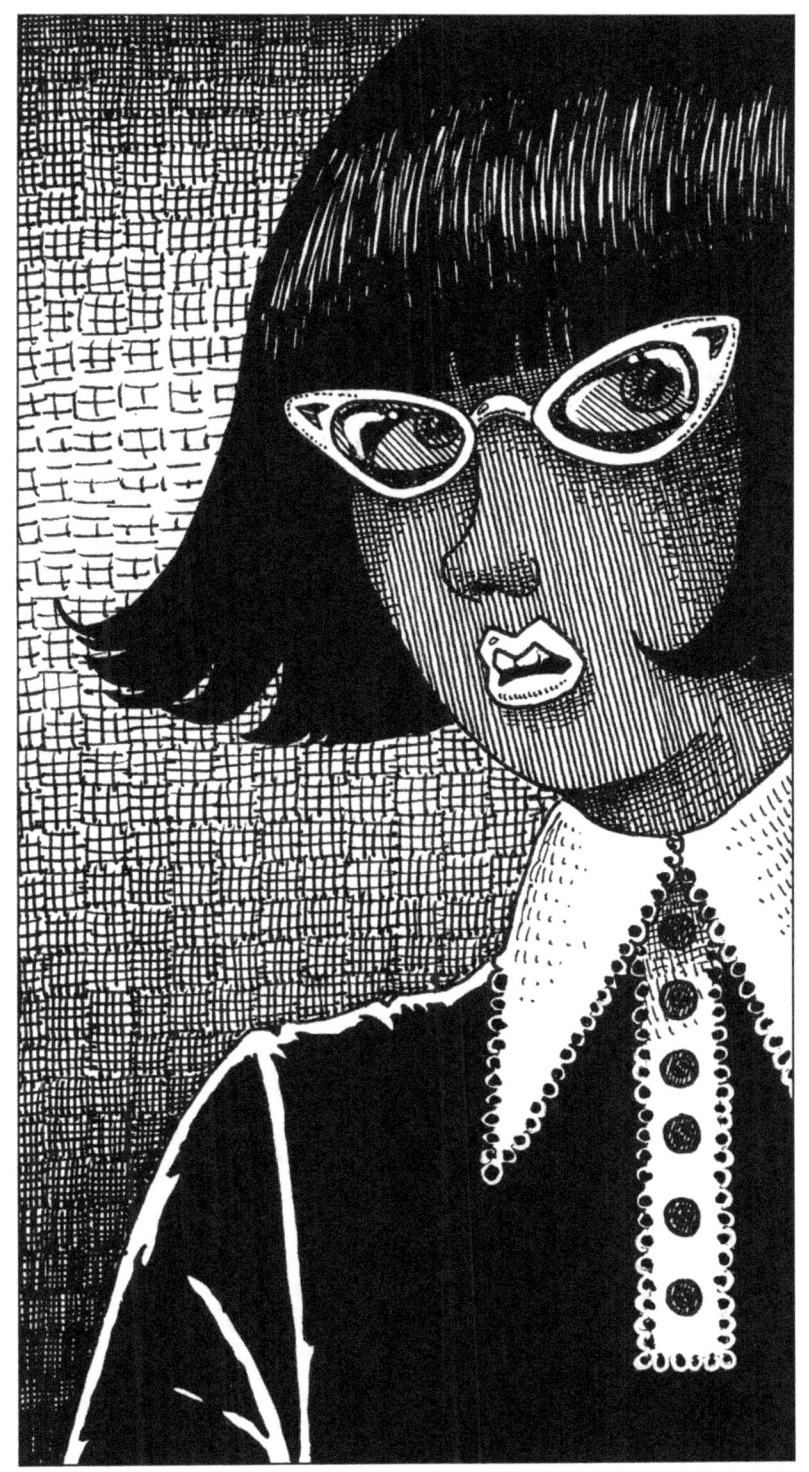

"…as every emancipated girl, Karen didn't want to be something like 'a fiancée'. She wanted her freedom. One day gave me back my flat keys and said: 'here are your keys, darling. I'm leaving, now', and off she went…"

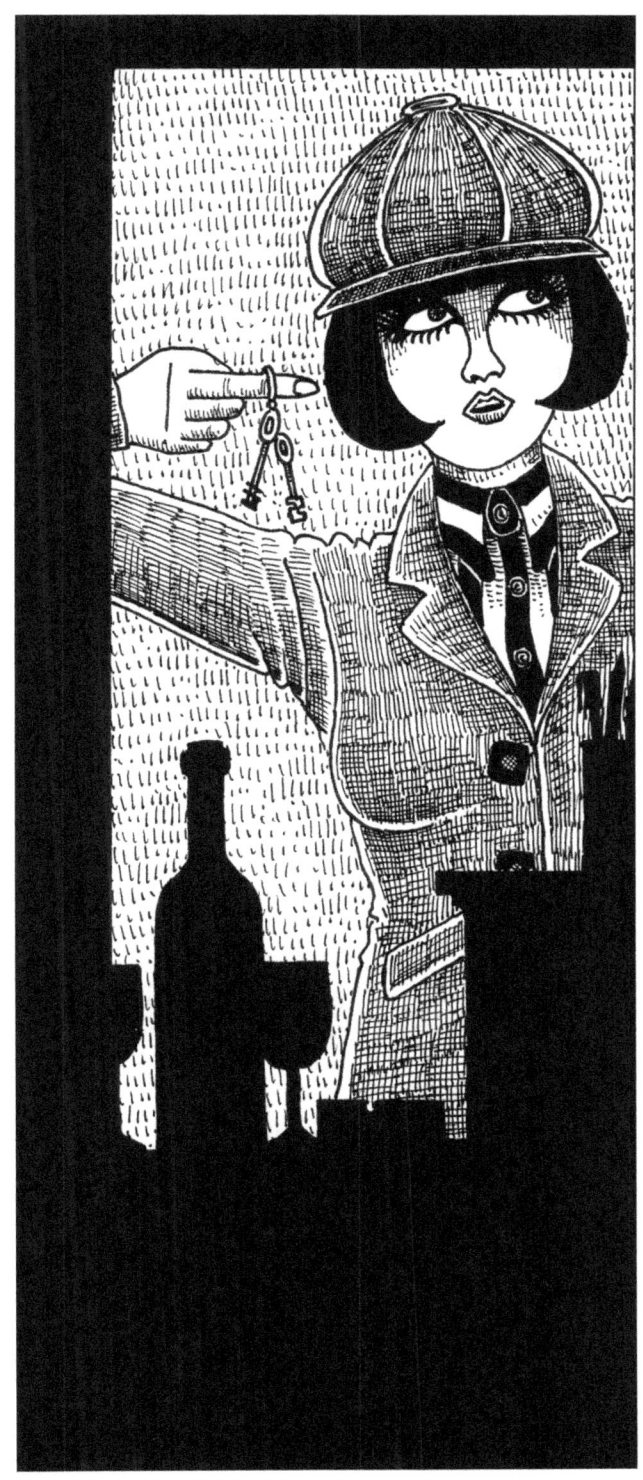

"…I knew this girl in a coffee bar. 'Would you like an Italian coffee?', I asked her. She didn't say a word, but I understood how lonely she felt…"

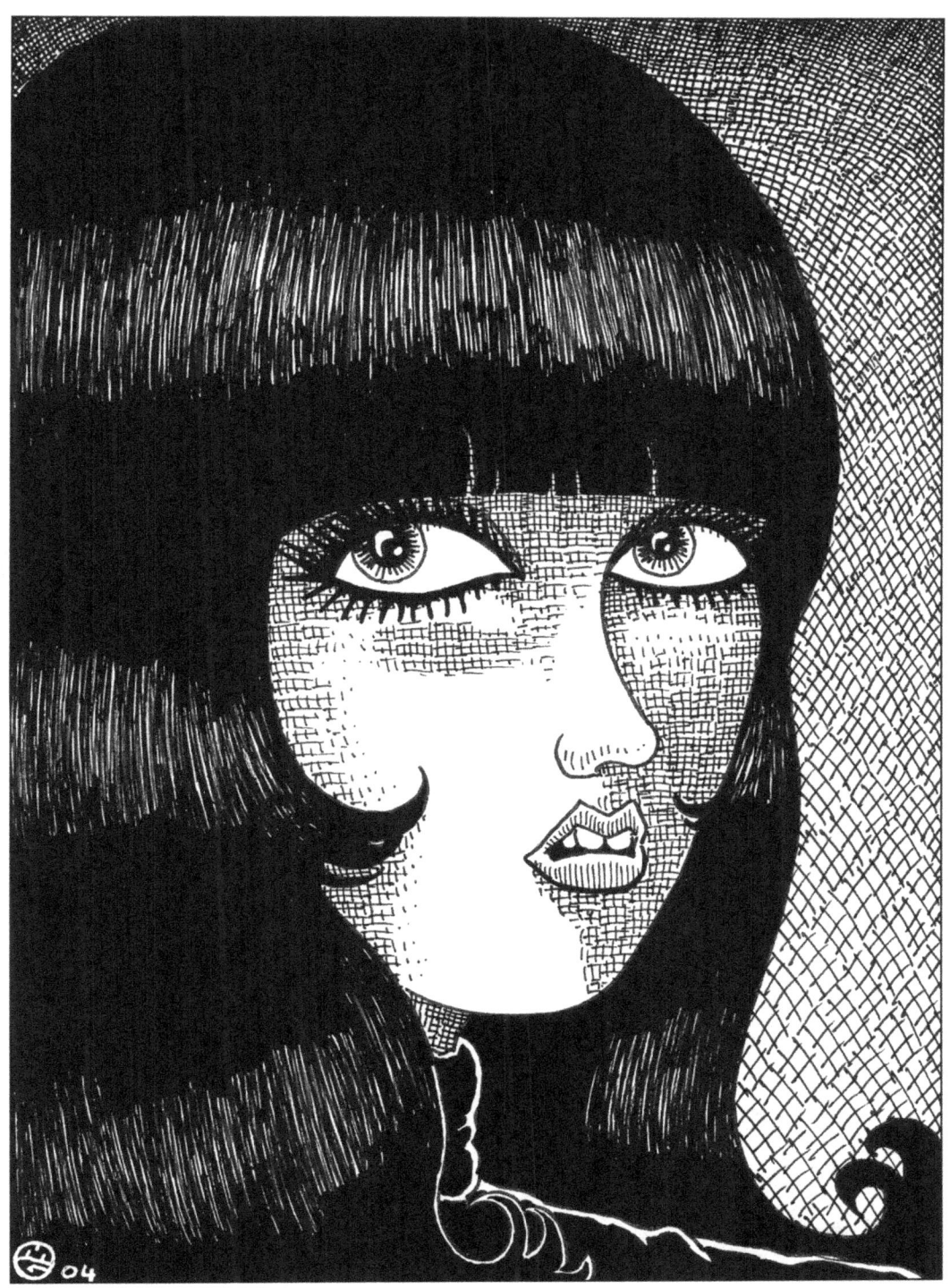

"...apart from being a pretty girl, Sarah was the perfect portrait of the 'Carnaby Street style'. Optical and geometrical art had no secret for her..."

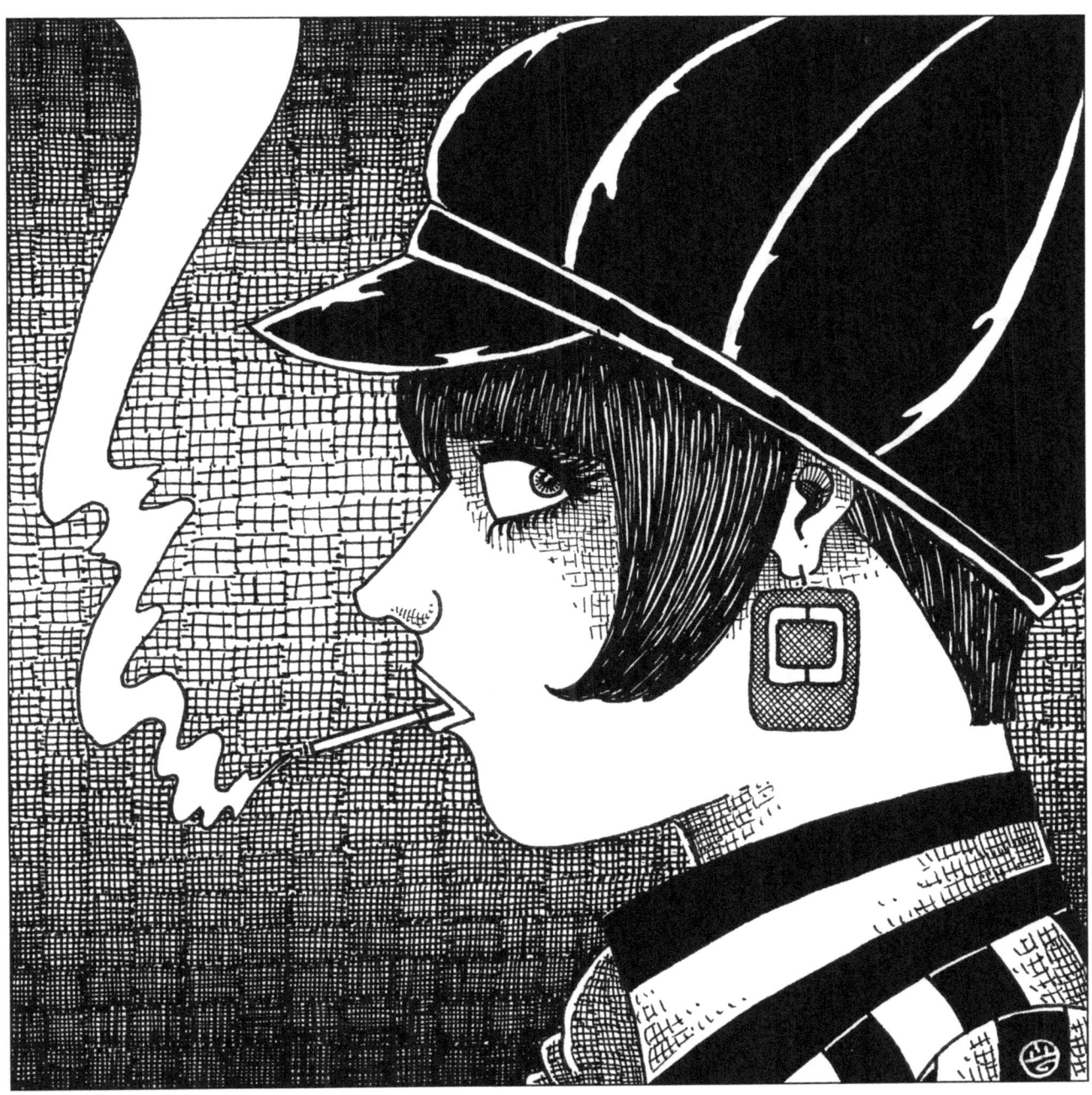

"...she was not far from the bus stop. That girl with candy-stripe hipsters was attracted by everything that moved around. 'Are you waiting for someone?', I asked. 'No, I'm just waiting'..."

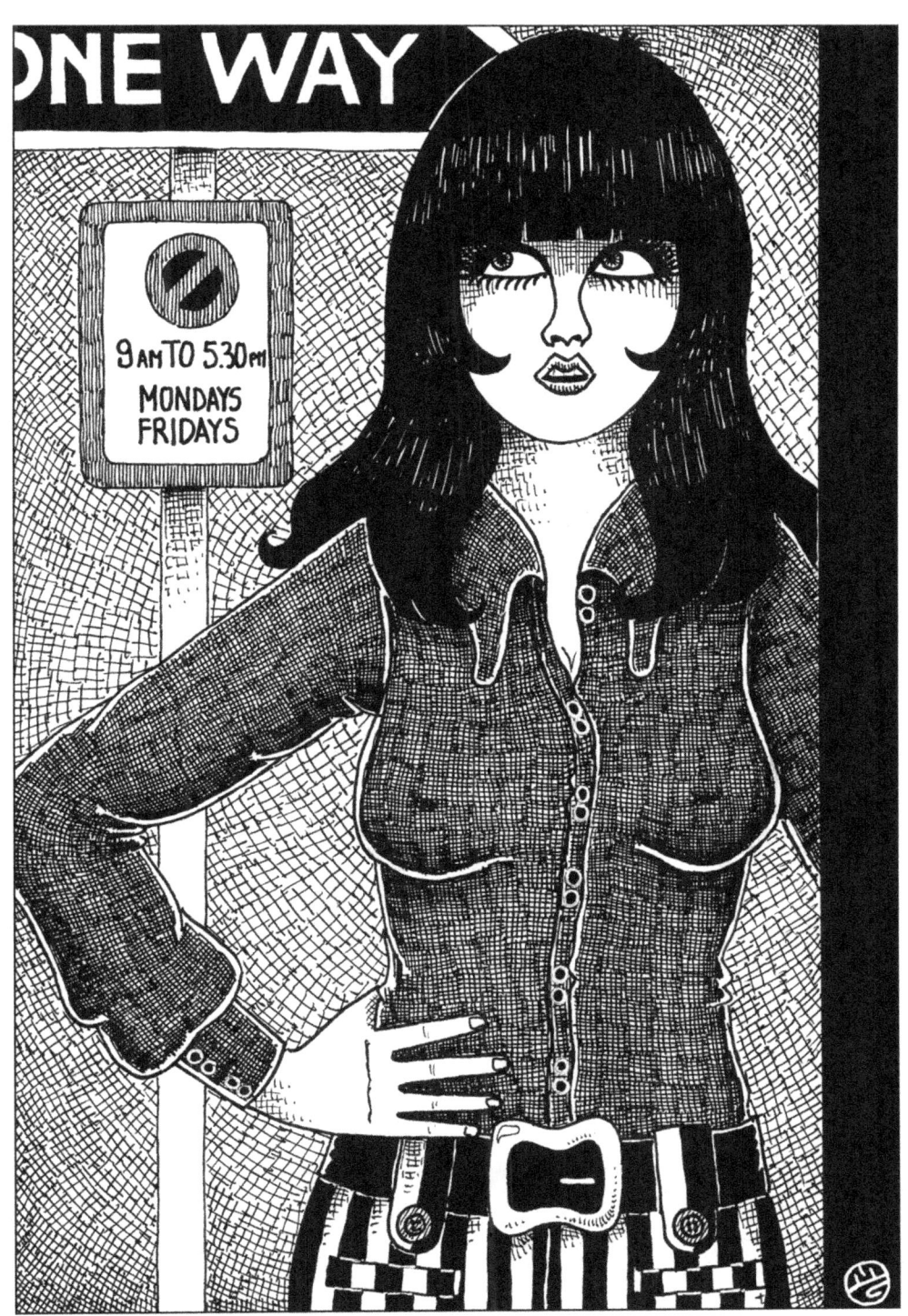

"...very few girls I've known like her. She was stylish and very well educated. I found myself many times talking about philosophy and literature with her, but also about music and clublife..."

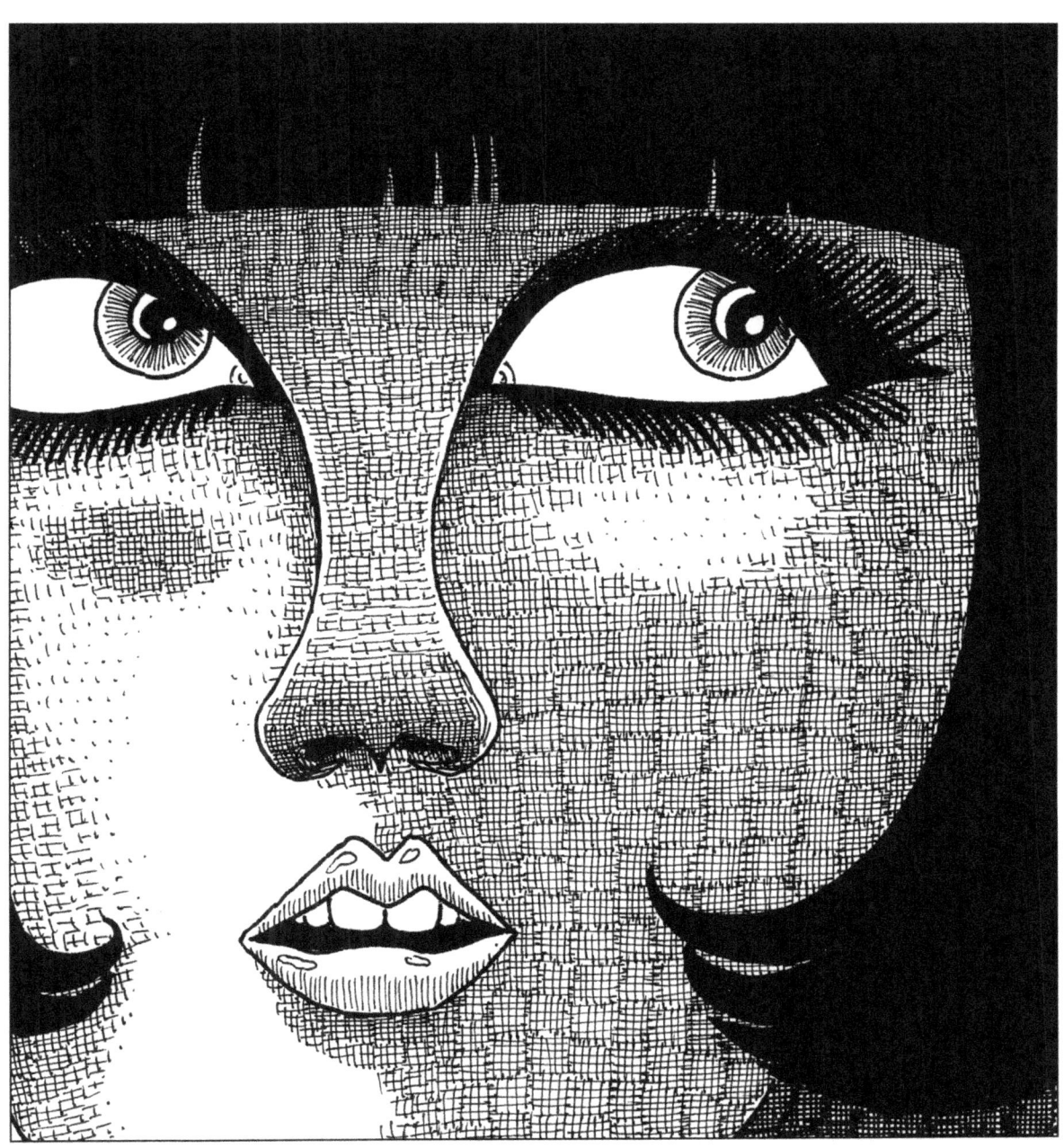

a conversation with max galli*

EyePlug: What first inspired you to veer towards the world of Art, Design and Illustration?

Max Galli: *I think women (aunts, cousins, acquaintances, some girls and women around…) must have been one of the main sources of inspiration, so far. Along with late 60s-mid 70s TV shows like UFO, Space:1999 and Doctor Who (the Tom Baker one), since I was seriously impressed by the design of furnishings and environments.*

EP: What are some of your early reference points and how have they grown or changed over time?

MG: *My reference points have always been quite diverse. When I was a child, it was basically my father's pictures of models, actresses and landscapes from the 60s and 70s. A few years after, when I was in my early teens, it was comics. I became a very good comic strips reader and collector, focusing my imagination on the 1965-1975 graphic style, you know, the likes of Crepax, Peellaert, Forest, Moebius, Rostagno, Maroto, Pazienza. In my late teens it was fine arts and illustration: Alphonse Mucha, John Waterhouse, William Morris, the Preraphaelites, the whole Art Nouveau phenomenon, Art Déco, Bauhaus, Op-Art…*

EP: What form does your modern work tend to take?

MG: *Well, I love drawing 60s-style pin ups! The female characters I draw are always sexy and sweet at the same time, and never too explicit – I think eroticism is an imaginative issue, not a blatant one. I have my wife and a lot of friends and acquaintances who – sometimes unconsciously – inspired me.*

EP: What sort of themes, mediums and techniques do you employ?

MG: *The main theme has always been the 60s-early 70s, since I was 19. You can't really stop me being fascinated by that period, can you? My favourite media are pigment ink pens and ProMarker and Pantone markers, which I only use on Letraset marker paper. I never used a computer for my illustrations, nor I ever used Photoshop for colouring. I'm an old school cat.*

EP: What has been the re-action and feedback so far to what you try to do?

MG: *Honestly, I have a few thousand fans from all over the world, but a good 60% of them are from English-speaking countries (UK, USA, Canada, Australia). The funny and amazing thing is that many of them are from outside the International Mod-60s Scene.*

EP: Have you managed to exhibit or publish your work so far, and if so how and where?

MG: I was lucky enough to have quite a few exhibitions around (three in London, one in Spain, 4 in Italy) and I published my first illustration back in 1994, for an Italian literary magazine. There are also a few books of mine around, the latest one, "Midnight To Six" is having a great success, both with public and critics.

EP: What other factors come into play whilst in the process of creating a new piece?

MG: It just depends on how I feel in that precise moment. Inspiration and music play a fundamental role, though. Usually I listen to some slow, sweet hammond organ stuff. Things like 60s-70s library music, 60s easy listening in general...

EP: How do you spread the word about what you do and who you are, as an Artist?

MG: Usually I do this through facebook and my own website. But I also like to know new people and meeting friends and keeping them updated about what I do.

EP: Have you collaborated on other Art based projects, if so who with and what was the outcome?

MG: I tried to join other project with other people, but I think that like mindness should be an important factor to make people work well together.

EP: Who else do you rate from the world of Art, Design and Illustration both past present and future?

MG: I'd say US illustrators Peter Max and Bob Peak and Spanish Luis Roca and Esteban Maroto, Italian designers Joe Colombo and Anna Castelli Ferrieri for the past times, for now and the future there's a great choice of very good artists, I can only remember a few names, but I like their artwork: Steven Millington, Marty Street and Kristian Hughes from UK, Alex Barbarroja and Marcos Torres from Spain, Sam Paglia from Italy and a few others from both sides of the sea.

EP: Does your work ever get you into trouble at all?

MG: Well, it happened sometimes. For example, I had a MySpace profile blocked four years ago, because of the naked women I showed in my illustrations. They didn't like my illustrations, so I didn't like being on MySpace. As a result of them blocking my art, I'm not using MySpace since then.

EP: What are your future plans?

MG: It just depends on what the future will bring me. You know, if I have the chance of doing something interesting, I'll just do it.

* Interview published on the British online magazine EyePlug, april 28th 2012. © EyePlug Magazine, 2013.

reviews

press and magazines

"Illustrations and thoughts about the Mod Scene from our very own Max Galli who will premiere drawings from this exhibition at www.euroyeye.es in Gijon between 16 July and 19 August at Cleo Modern & Vintage Clothing, C/Antonio 14, Gijon, Spain. Thirty four black and white modernist inspired illustrations included in this book from the hand of Max appropriately entitled 'Midnight To Six'. The content is usually beautiful ladies, sometimes with the guys, on scooters or inside club's where you find most self respecting Mod's and always dressed sharp. Influenced by his father who was a keen photographer this labour of love features drawings inspired by fellow scenesters who Max met on his journey starting in London back in 1999. The attention to detail makes this a must buy for those who collect modernist inspired paintings or books." - THE NEW UNTOUCHABLES, UK

"Midnight to six by Max Galli - An illustration book.
Max is an unique artist from Italy, he's definitely a 60s pop era lover! An Illustrator, a journalist, a writer, a clubber, a doll maker! This edition of Midnight to six, is the second of a very desirable original book published in 2002. SO it's the last chance to add it in your art-book collection. Illustrations and thoughts about the mod scene." - UBU POP LAND, Germany

"Midnight To Six, illustrations about the Mod Scene.
Max Galli (illustrator , journalist , graphic designer , writer , ...) has published a book of black and white illustrations on the mod scene, accompanied by notes or reflections. The Italian has over 20 years of experience focused on a pop art style, fascination with modernism and 60s and also with some forays into the world of comics. Galli has realized numerous works related to music or the scene, including album covers, concert or club posters, magazine illustrations, as well as being heavily involved in modernism from his time in London in the late 90s." - RITMO SOUL Y OTROS MODERNISMOS, Spain

readers

"Such a perfect coffee table book to always be on display. I love the cover, the color and the title match perfectly. The illustrations are beautiful and inspiring. A must have for people who love fashion and music and a time when those two things were the only things that mattered." - Katie Rinaldi, USA

"Midnight To Six... I got it and I'm soooo pleased with it!! Not a comic, not a photobook, not a documantary, not a novel,...but: a bit of it all!! As detailed as a photo can be, Max Galli gives every detail the value it needs to get... You open the book and dive into the 60s straight away!!! All these portraits are so stylish...full of love for the decade and their fashionable people. The little texts match perfect to what you can see, If you see Max illustrations you feel like ordering new dresses or suits from your taylor... a must have!!!" - Beatrix Nagel, Germany

All reviews have been published from february to september 2012.

...and that's me, at last.
Don't worry, I won't be long.
Just wanted to say 'thank you' to somebody.

Many thanks to my wife Kristina, for a lifetime of love and understanding.
Many thanks to Rob Bailey, for years of friendship and support, and to Carolina, his lovely wife.

Thanks to Barry @ Pip! Pip! Design for his huge support.
Thanks to Monique Condini for the inspiration about some illustrations.
Thanks To Félix Dominguez for the Euro Ye Ye exhibition.
Thanks to Mary Boogaloo for the introduction of the first edition of this book.

And thanks to: Mateata Peirsegaele, Irene Fazio, Dick Porter, Katie Rinaldi, Darenda Weaver, Beatrix Nagel, Adam Cooper, Rowed Out, Belle Vue Athens, The New Untouchables, Peter Mazzi, Özden Gültekin, Orlagh Bennett, Peter Feely, Morena Tait, Francesco D'Onofrio, Alessandro Detassis, Alessio "Bazza", Luca "Mathmos" Selvini and Simona Ratti, Moreno Spirogi, Joe Moran, Julye Hayward Cowley, Mike and Nicky Handy, Eron Falbo, Julie Babylui Robertson, Marty Street, Hugh Burns, Ilaria Bultrighini.

Not forgetting my friends and supporters in every part of the world, all my fans on Facebook, some occasional cats and chicks who were there when I needed.

For further information, please feel free to check my website:
www.maxgalli.net

and my Facebook page:
http://www.facebook.com/maxgalli.art

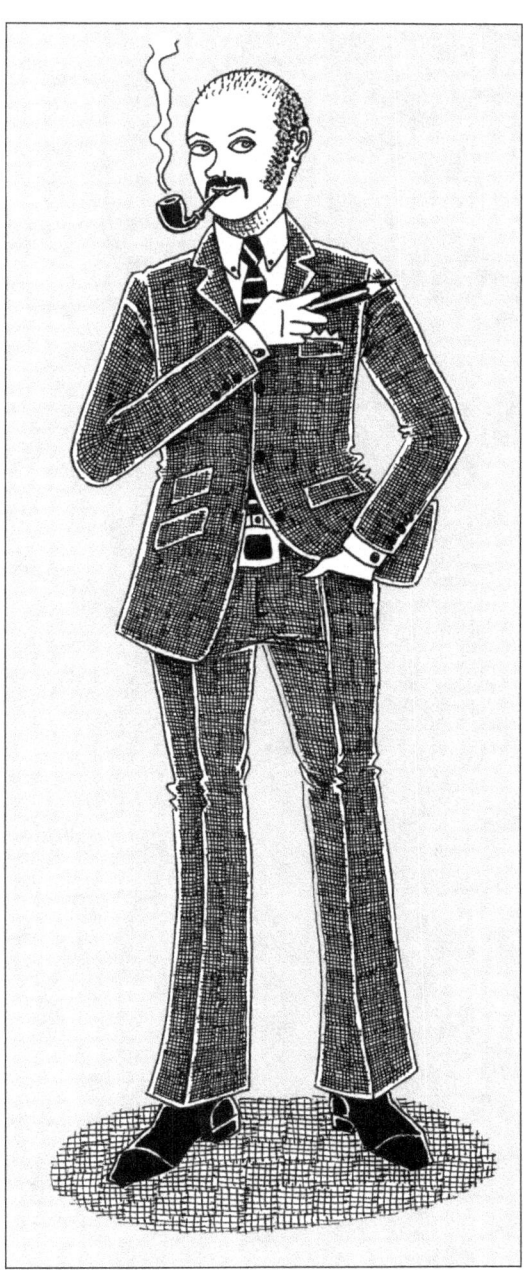

www.ingramcontent.com/pod-product-compliance
Lightning Source LLC
Chambersburg PA
CBHW080949170526

45158CB00008B/2423